IT'S THE

POLITICAL

ECONOMY,

STUPID

First published 2013 by Pluto Press
345 Archway Road, London N6 5AA
www.plutobooks.com

Pori Art Museum Publications 117
www.poriartmuseum.fi

Distributed in the United States of America exclusively by
Palgrave Macmillan, a division of St. Martin's Press LLC,
175 Fifth Avenue, New York, NY 10010

British Library Cataloguing in Publication Data
A catalogue record for this book is available from the British Library

ISBN 978 0 7453 3369 4 Pluto Press
ISBN 978 952 5648 36 2 Pori Art Museum
ISBN 978 1 8496 4867 7 PDF eBook

ISSN 0359 4327

Library of Congress Cataloging in Publication Data applied for

This book is printed on paper suitable for recycling and made from fully managed and sustained forest
sources. Logging, pulping and manufacturing processes are expected to conform to the environmental
standards of the country of origin.

10 9 8 7 6 5 4 3 2 1

Produced for Pluto Press by Chase Publishing Services Ltd
Typeset and designed by Noel Douglas
Printed in the European Union by W&G Baird, Antrim, Northern Ireland.

All exhibition views at the ACFNY
Installation view at the ACFNY
Photos by David Plakke

All exhibition views at Centre of Contemporary Art, Thessaloniki
Photos by Oliver Ressler

IT'S THE POLITICAL ECONOMY, STUPID

The Global Financial Crisis in Art and Theory

Edited by:
Gregory Sholette
& Oliver Ressler

PlutoPress
www.plutobooks.com

8

Unspeaking the Grammar of Finance
Gregory Sholette and Oliver Ressler

1

14

It's the Political Economy, Stupid!
Slavoj Žižek

2

62

The Political Economization of Art
John Roberts

3

72

Derivative Days: Notes on Art, Finance, and the Unproductive Forces
Melanie Gilligan

4

Occupational Realism
Julia Bryan-Wilson

5

84

2a

Comments on Art from the Exhibition
It's the Political Economy, Stupid
Liz Park

34

Foreword by Pia Hovi-Assad,
Pori Art Museum, Finland

6

CONTENTS

Foreword

Pia Hovi-Assad

Exhibition curator,

Pori Art Museum,

Finland

How tiny Finland could bring Euro crisis to an end...

A "Spanic," followed by a "Quitaly," followed by a "Fixit." A fresh panic in Spain might be followed by rising demands for Italy to quit if it doesn't get the same terms its fellow Mediterranean country has been offered, followed by a Finnish departure from the euro that might finally bring the whole saga to a climax. It would be a rough ride – and you wouldn't want to be holding many assets other than dollars or gold or possibly Swiss francs while it was playing itself out. But at least it might bring a resolution to the crisis.

Matthew Lynn, The Wall Street
Journal's Market Watch (June 6, 2012)

Due to the country's isolated location, influences have always arrived in Finland a few years later than central Europe. The impact of American and European political art was felt in the Finnish art scene at the end of the 1960s. The main themes in Finnish visual art in the 1960s and 1970s were ecological and social, focusing on issues of current interest in Finland. One young artist who attacked the bourgeois values of society at the time was Harro Koskinen (b. 1945). He created a gaudy fat pig to mock the middle class. Koskinen's *The Pig Coat of Arms* (1969) caused an uproar and charges were brought against him for mocking the Finnish coat of arms. The case was taken to court and Koskinen received a fine.

In the 1970s, Koskinen created a number of works featuring the Finnish flag. The artist stretched, perforated, tore, crumbled, cut and shrank the Finnish national symbol. He splashed it with blood and finally set it on fire, turning the flag into a black liquid mass. Koskinen was prosecuted also for this series of works, but the charges were eventually dropped.

The Finnish public voted "yes" for the European Union in 1994, and Finland acceded to the EU in 1995. Finland joined the eurozone in 2002. Owing to these big changes in Finnish society, and also the impact of the internet, the art scene in Finland today is intrinsically more global than in the 1960s and 1970s. The themes in current political Finnish art are global and local.

Burak Arikan's *Network Map of Artists and Political Inclinations*, presented at the 7th Berlin Biennale in 2012, included several Finnish artists. In November 2010, curator Artur Żmijewski announced an open call to artists from all over the world, asking them to send in artistic material as part of research for the 7th Berlin Biennale. In addition to standard information usually requested in such a call, it also asked the artists to state their political inclination. The biennale received over 5,000 submissions in reaction to the call. Burak Arikan's network map features 4,592 artists and 395 unique political inclinations. From Finland, 20 artists are included in the map. In view of the approximately 3,000 visual artists currently active in Finland, the number is not very large. These 20 artists included in the work all report being leftish, green and/or feminist. They represent various medias, and are based in Helsinki, Tampere, Turku and Pori. One of the Pori-based artists is Marko Lampisuo, whose work *The End of Landscape* (2012) will be included in the *Net Gain!* exhibition series in the Pori Art Museum in the autumn 2012. Another

artist featured in the series is Pori-based Laura Lilja. Laura Lilja investigates social power structures, gender and sexuality in works that are based on queer theory, post-feminism and activism.

I recently visited the Documenta (13) in Kassel. Among the vast selection of artworks featured in the show, there was one which struck to the very core of the present state of the world. It was a video entitled *Time/Bank* by e-flux: Julieta Aranda and Anton Vidokle. The video is an examination of alternative currencies, mutualism, and the Marxian labor theory of value. The message is that it is important to go beyond the idea that we are facing merely a problem of money, numbers, and algorithms. The crucial thing is that countries and people around the world are all connected through complex array of models and systems that are globally stretched. I am looking forward to seeing what alternatives the works in the exhibition *It's the Political Economy, Stupid* will offer us. I have no doubt that the show will turn out to be a milestone for the political art scene in Finland. I am also hoping that it will give new food for thought and serve as a platform for current discussion in Finland.

The President of Finland, Sauli Niinistö, recently gave an interview in which he said he spoke for the majority of Finns. According to him, there is a popular opinion among Finns that Finland has shown greater solidarity than most eurozone countries in the current financial crisis (*Satakunnan Kansa*, June 16, 2012), even though most Finns pay more taxes than people in other EU countries. In Niinistö's opinion "a country is not rich or poor, it only reflects how the economy of the state is run." He said he hopes that the financial crisis in Europe will not lead to a situation in which we will begin talking about the fall of democracy.

There are activists and citizens, especially in the capital region, who would like to be independent of large corporate controlled economies. This heterogeneous group would like to see solidarity that is not geographically bound, and they are already creating their own alternative economies with non-monetary systems of exchange. In other words, there are in Finland immaterial currencies that create utopian subcultures. If and when, and how, these currencies will ever be used by the majority remains to be seen.

The exhibition *It's the Political Economy, Stupid* has been on tour in 2012 in the Austrian Cultural Forum New York and the Contemporary Art Centre of Thessaloniki. The Pori Art Museum would like to thank all the partners as well as Commissioning Editor David Castle of Pluto Press for excellent cooperation.

The Pori Art Museum also wishes to express its warmest thanks to exhibition curators Oliver Ressler and Gregory Sholette for their dedicated contribution to the realization of the exhibition and the book.

Special thanks are also due to all of the participating artists.

1

Unspeaking
the Grammar
Of Finance

Gregory Sholette
& Oliver Ressler

At dinner parties, in the bedroom, on vacation, **we speak with the grammar of finance**. Liquidity is estimated, investment potential praised, derided, exaggerated.

Even Occupy Wall Street talks about "stakeholders" in its decision-making processes, and refers to "creative factories," all the while no less symptomatically using percentage points to illustrate what is wrong with modern society. Which is to say that being in the world now means being worthy of capitalization. And as the language of ultra-deregulated capitalism penetrates every detail of our lives it has emerged as the default medium of our very self-expression, becoming a kind of toxic mortgage of the soul. *It's the Political Economy, Stupid* represents not so much a refusal of this new reality, but an object lesson in backtalk, of impertinence objectified. It is both a book, and a series of contemporary art exhibitions organized by the two editors of this volume. Both the book and the exhibition owe their titles to philosopher Slavoj Žižek's impudent re-spinning of Bill Clinton's 1992 presidential slogan, "It's the Economy, Stupid." What Žižek argues in brief is that ideological narratives are capable of shifting attention away from capitalism's cyclical contractions and refocusing collective attention onto the realm of law, politics, and culture (his entire essay is reproduced in this volume). The aspiration of *It's the Political Economy, Stupid* is to countermand that particular narrative through the auspices of visual art and critical theory. And while we make no claims that either art or theory has given post-Fordist ideology the "slip," the artists and authors selected for this project do actively seek to disable "econospeak," even as it in turn spins round to speak from within the very gristle and marrow of their being and practice. This is just one level of entanglement *It's the Political Economy, Stupid* has churned up in its wake. Still another is our role as combined artists and curators, an advantageous position certainly, but one made possible by the very processes we aim to critique.

It has been some 35 years since neoliberal capitalism accelerated the systemic theft of public resources, including the hyper-deregulation of markets, and a mercenary assimilation of global resources. During this time most of the world's governments have partly or wholly abandoned their previous roles as referees for the security of the majority, identifying instead with the profiteering interests of the corporate sector. When problems in the US real estate and financial sectors resulted in a global financial arose four years ago, nations all over the world pumped trillions of dollars into banks and insurance companies, essentially creating the largest transfer ever of capital into the private sector. Today, we are facing a catastrophe of capitalism that has also become a major crisis of representative democracy. Žižek puts it this way:

the main task of the ruling ideology in the present crisis is to impose a narrative which will not put the blame for the meltdown onto the global capitalist system AS SUCH, but on its secondary accidental deviation (too lax legal

regulations, the corruption of big financial institutions, etc.).[1]

Not surprisingly, it is the social order itself that has come to resemble a new species of modern ruin as deterritorialized finance capital melts all that was solid into raw material for market speculation today, and biopolitical asset mining tomorrow. Nor has art has escaped this upheaval. Claims of its elevated status notwithstanding, the objects, documents, ideas, and proper names associated with high culture increasingly resemble a special asset class designed primarily for the investment needs of the so-called *1 percent* (and several contributors to this volume make similar assertions).

According to investment firms like Artists Pension Trust or cultural indices like the Mei Moses® rate an artist's market value by measuring his or her presence in A-rated galleries, museum collections, auction sales, reviews, grants, and so forth. Even art-world buzz matters when it comes to establishing investment potential. Mainstream financial corporations such as UBS, Deloitte, and Merrill Lynch have joined this armada, some linking multiple artworks into bundled trading instruments not unlike toxic mortgage securities. It was only a matter of time before this new economic realism reached past financiers, dealers, collectors, and art fairs into art practice itself. Examples abound, ranging in tone from Michael Landy's innocuous credit card-eating machine at last year's *Frieze* Art Fair, to Damien Hirst's unsavory metamorphosis into *Damien Hirst, the Hedge Fund*. By contrast, the works gathered together for *It's the Political Economy, Stupid* represent something else. Call it an attempt at pushing back against the austerity measures of disciplinary capitalism, or merely the right to an anguished scream, a privilege Adorno later appended to his oft-cited commentary "writing poetry after Auschwitz is barbaric." Significantly, the last time so many artists directly addressed issues of economics through their practice was just before and during the last great depression in the 1920s and 1930s. And if you will permit us a dollop of Marxist indelicacy now, is it possible that the old *idée fixe* in which artistic production is determined by the economic base has not so much been justified in this latest economic crisis, but rather it has instead become an inescapable visage within the realm of the cutural superstructure, like the walking dead, awkwardly showing up, disturbing the scene, all the while making it impossible to avoid previously ignored processes of value formation. One important difference from the last major economic crisis is that in the 1920s and 1930s artists and intellectuals often chose to identify with a well-organized anti-capitalist Left. In the years since then, not only has the Left become disorganized, and the definition of the working class become less precise, but within the realm of culture divisions of labor — including those between curator, artist, and collector — have broken down and blurred. Not without irony, this ambiguity is the outcome of the art world's version of

deregulation on several levels.

Following the 1987 stock market crash the market turned down, the careers of several high-profile artists noticeably plunged, and prices for contemporary work went into free-fall. But the crisis was short-lived. Speculators, dealers, and collectors soon found their footing again as a new division of power took shape within high culture's management, reception, and production. "The era of the curator has begun," wrote *New York Times* art critic Michael Brenson in 1998 at a moment when the status and number of independent curators jumped to a new level of visibility. Together with unprecedented auction sales, an expanding network of international fairs and biennials sent peripatetic curators in search or unseen cultural treasures. Geo-global outposts and inner-city neighborhoods were scoured for new talent. And yet, to merely ascribe this shift solely to post-Fordist, hyper-entrepreneurialism is to forget that the 1990s also played midwife to another cultural tendency that was less object-oriented, and not infrequently political in its intent. Numerous forms of project-based, process-oriented, self-organized, and socially critical art emerged into view in the 1990s, even if it would be another decade at least before these activities gained even minimal mainstream recognition. What was happening was that the art scene, in spite of itself, had become politicized. Irreversibly, one could argue. Artistic production became increasingly theoretical, perhaps even managerial, and at times began to resemble curatorial work itself. Thus two kinds of self-awareness — one recognizing the omnipotent presence of the market, the other recognizing art's ideological constitution — began to confront each other. Previously stalwart barriers between artist, audience, and curator trembled, blurred, blended. Artists increasingly occupied the position of curator, becoming "artist-curators," a development that appears in retrospect logical, if not inevitable (though not without friction, or a lingering asymmetry of power and status). At the same time art institutions began to resemble components of a "system" to be used and occupied, an interpretation of cultural power admittedly quite different from many political art precursors who confronted the art world as strictly enemy terrain. *It's the Political Economy, Stupid* is just such an artist-curated occupation. But in contrast with the exuberance of capital's largest-ever bubble economy, the previous so-called "curatorial era" is beginning to reflect a post-effervescent sobriety. For as much as a certain new interest in realism is evident amongst many artists, including those in our exhibition, so too is a noticeable blending of verisimilitude and fantasy, an aesthetic or paradox and contradiction. And just as the capitalist crisis appears nowhere in sight, so too the necessity of defining and resisting the narratives of dissimilitude that Žižek warns of remains an ongoing task. We hope this book takes a step in that direction.

It's the Political Economy, Stupid originated with a curatorial

invitation to artist Oliver Ressler from Andreas Stadler, the director of the Austrian Cultural Forum, New York (ACFNY). Little more than a year into the Global Financial Crises Gregory Sholette joined the curatorial team. *It's the Political Economy, Stupid* launched a preview exhibition at Open Space in Vienna (March 16–April 25, 2011), which included four artists and a year later its major manifestation took place at the ACFNY (January 24–April 22, 2012), where we included works by eleven international artists or artists' groups. Although ACFNY is not an independent art space, but is instead an institution linked directly to a diplomatic representation of a state, Stadler managed to run a program of ambitious and sometimes political exhibitions that often get attention on a national and international level. Adding still more artists to the exhibition *It's the Political Economy, Stupid* then traveled to the Centre of Contemporary Art in Thessaloniki, Greece (June 27–October 14, 2012), a country in the throes of the European Union's branch of the international capitalist meltdown. The fourth destination of the exhibition was the Pori Art Museum, Pori, Finland (February 1–May 26, 2013). Even as we write this, new artists and venues are being added to the project in the years ahead. With the publication of this book made possible with the generous assistance of the Pori Art Museum, a second axis of critique is added to that of the exhibition. Its theoretical dimensions enter into a discursive rejoinder with the artist's videos, graphics, and sculptural objects. Ideally the result is an expansion of both. It is our hope that the works documented in this volume, together with the essays and critical commentary, form the constituents of a developing research model born from crisis, but pointing towards the horizon of a very different world, and a very different language of life.

We would like to extend thanks to David Castle, Tracey Dando, and the entire team at Pluto Press, as well as Matthew F. Greco for his help preparing the manuscript.

Note

1. Slavoj Žižek, "It's the Political Economy, Stupid!," in Gregory Sholette and Oliver Ressler, eds., *It's the Political Economy, Stupid*, London: Pluto Press, 2013, p. 17.

2

It's the
Political
Economy,
Stupid!¹

Slavoj Žižek

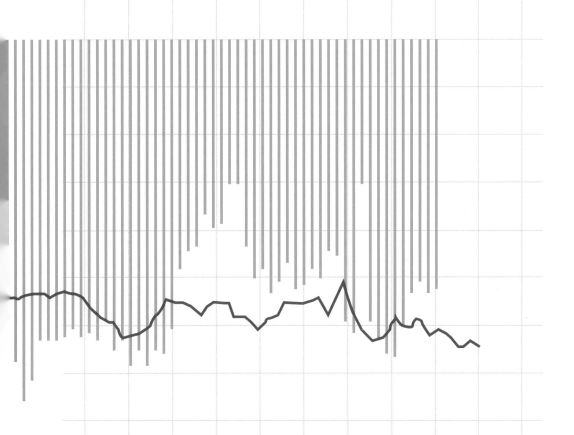

Two events mark the beginning and end of the first decade of the twenty-first century: the 9/11 attacks in 2001 and the financial meltdown in 2008.

The language President Bush used, in both instances, to address the American people sounds like two versions of the same speech. Evoking the threat to the very American way of life, and the necessity for fast and decisive action to cope with the danger, he called for the partial suspension of core US values — guarantees to individual freedom and market capitalism — to save these very values. Where does this similarity come from? The Francis Fukuyama utopia of the "end of history" — the belief that liberal democracy had, in principle, won and the advent of a global, liberal world community lies just around the corner — seems to have had to die twice: the collapse of the liberal democratic political utopia on 9/11 did not affect the economic utopia of global market capitalism. If the 2008 financial meltdown has a historical meaning, it is as a sign of the end of the economic aspect of the Fukuyama utopia.

The first thing that strikes the eye in the reactions to the financial meltdown is that, as one of the participants put it: "No one really knows what to do." The reason is that expectations are part of the game: how the market will react depends not only on how much the people trust the interventions, but even more on how much they think others will trust them — one cannot take into account the effects of one's own interventions. Long ago, John Maynard Keynes nicely rendered this self-referentiality when he compared the stock market to a silly competition in which participants must pick only a few pretty girls from a hundred photographs; the winner is the one who chose girls closest to the general opinion: "It is not a case of choosing those which, to the best of one's judgment, are really the prettiest, nor even those which average opinion genuinely thinks the prettiest. We have reached the third degree where we devote our intelligence to anticipating what average opinion expects the average opinion to be." So we are forced to choose without having at our disposal the knowledge that would enable a qualified choice, or, as John Gray put it: "We are forced to live as if we were free."

Joseph Stiglitz recently wrote that, although there is a growing consensus among economists that any bailout based on Paulson's plan [editors' note: the bailout plan for the US devised by Treasury Secretary Henry Paulson in 2008] won't work, "it is impossible for politicians to do nothing in such a crisis. So we may have to pray that an agreement crafted with the toxic mix of special interests, misguided economics, and right-wing ideologies that produced the crisis can somehow produce a rescue plan that works — or whose failure doesn't do too much damage."[2] He is right, since markets are effectively based on beliefs (even beliefs about other people's beliefs), so when the media worry about "how the markets will react" at the bailout, it is a question not only about the real consequences of the bailout, but about the belief of the markets into the plan's efficiency. This is why the bailout may work even if it is economically wrong.

The pressure "to do something" is here like the superstitious compulsion to do some gesture when we are observing a process on which we have no real influence. Are our acts not often such gestures? The old saying "Don't just talk, do something!" is one of the most stupid things one can say, even measured by the low standards of common wisdoms. Perhaps, we were lately doing too much, intervening, destroying environment...and it's time to step back, think and say the right thing. True, we often talk about something instead of doing it — but sometimes we also do things in order to avoid talking and thinking about them. Like quickly throwing $700 billion at a problem instead of reflecting on how it arose.

It's Ideology, Stupid!

Immanuel Kant countered the conservative motto "Don't think, obey!" not with "Don't obey, think!", but with "Obey, BUT THINK!" When we are blackmailed by things like the bailout plan, we should bear in mind that we are effectively blackmailed, so we should resist the populist temptation to act out our anger and thus hit ourselves. Instead of such impotent acting out, we should control our anger and transform it into a cold determination to think, to think in a really radical way, to ask what kind of a society are we living in, in which such blackmail is possible.

Will the financial meltdown be a sobering moment, the awakening from a dream? It all depends on how it will be symbolized, on what ideological interpretation or story will impose itself and determine the general perception of the crisis. When the normal run of things is traumatically interrupted, the field is open for a "discursive" ideological competition — for example, in Germany in the late 1920s, Hitler won in the competition for the narrative which would explain to Germans the reasons for the crisis of the Weimar republic and the way out of it (his plot was the Jewish plot); in France in 1940 it was Maréchal Pétain's narrative which won in explaining the reasons for the French defeat.

Consequently, to put it in old-fashioned Marxist terms, the main task of the ruling ideology in the present crisis is to impose a narrative which will not put the blame for the meltdown onto the global capitalist system AS SUCH, but on its secondary accidental deviation (too lax legal regulations, the corruption of big financial institutions, etc.).

Against this tendency, one should insist on the key question: which "flaw" of the system AS SUCH opens up the possibility for such crises and collapses? The first thing to bear in mind here is that the origin of the crisis is a "benevolent" one: after the digital bubble exploded in the first years of the

new millennium, the decision across the party lines was to facilitate real estate investments in order to keep economy going and prevent repression — today's meltdown is the price paid for the fact that the US avoided a recession five years ago. The danger is thus that the predominant narrative of the meltdown will be the one which, instead of awakening us from a dream, will enable us to continue to dream. And it is here that we should start to worry — not only about the economic consequences of the meltdown, but about the obvious temptation to reinvigorate the "war on terror" and US interventionism in order to keep the economy running. Or, at least, to use the meltdown to impose further tough measures of "structural readjustment."

An exemplary case of the way the meltdown already is used in ideologicopolitical struggle is the ongoing struggle for what to do with General Motors (GM) — should the state allow its bankruptcy or not? Since GM is one of the institutions which embody the American dream, its bankruptcy was long considered unthinkable — but more and more voices now refer to the meltdown as that additional push which should make us accept the unthinkable. The NYT column "Imagining a G.M. bankruptcy" ominously begins with:

As General Motors struggles to avoid running out of cash next year, the once unthinkable prospect of a G.M. bankruptcy filing is looking a lot more, well, thinkable.[3]

After a series of expected arguments (the bankruptcy would not mean automatic loss of jobs, just a restructuring which would make the company leaner and meaner, more adapted to the harsh conditions of today's economy, etc.), the column dots the i towards the end, when it focuses on the standoff "between G.M. and its unionized workers and retirees": "Bankruptcy would allow G.M. to unilaterally reject its collective bargaining agreements, as long as a judge approved." In other words, bankruptcy should be used to break the backbone of one of the last strong unions in the US, leaving thousands with lower wages and other thousands with lower retirement sums. Note again the contrast with the urgency to save the big banks: here, where the survival of thousands of active and retired workers is at stake, there is, of course, no emergency, but, on the contrary, an opportunity to allow free market to show its brutal force. As if the trade unions, not the wrong strategy of the managers, are to be blamed for the GM troubled waters! This is how the impossible becomes possible: what was hitherto considered unthinkable within the horizon of the established standards of work decency and solidarity should become acceptable.

Marx wrote that bourgeois ideology loves to historicize — every social,

religious, cultural form is historical, contingent, relative — every form with the exception of its own.

There WAS history, but now there IS no history. With capitalist liberalism, history is at an end, the natural form is found.[4] This old paradox of liberal ideology exploded with new power in today's apologies of the End of History. No wonder the debate about the limits of liberal ideology is so thriving in France: the reason is not the long French statist tradition which distrusts liberalism; it is rather that the French distance towards the mainstream Anglo-Saxon liberalism provides an external position which enables not only a critical stance, but also a clearer perception of the basic ideological structural of liberalism. No wonder, then, that, if one wants to finds a clinically-pure, lab-distilled, version of today's capitalist ideology, one should turn to Guy Sorman. The very title of the interview he recently gave in Argentina, "This crisis will be short enough,"[5] signals that Sorman fulfills the basic demand that ideology has to meed with regard of the financial meltdown: to renormalize the situation — "things may appear harsh, but the crisis will be short, it is just part of the normal cycle of creative destruction through which capitalism progresses." Or, as Sorman put it in another of his texts, "creative destruction is the engine of economic growth": "This ceaseless replacement of the old with the new — driven by technical innovation and entrepreneurialism, itself encouraged by good economic policies — brings prosperity, though those displaced by the process, who find their jobs made redundant, can understandably object to it." (This renormalization, of course, coexists with its opposite: the panic raised by the authorities in order to create a shock among the wide public — "the very fundamentals of our way of life are threatened!" — and thereby to make them ready to accept the proposed — obviously unjust — solution as inevitable.) Sorman's starting premise is that, in the last decades (more precisely, after the fall of Socialism in 1990), economy finally became a fully tested science: in an almost laboratory situation, the same country was split into two (West and East Germany, South and North Korea), each part submitted to the opposite economic system, and the result is unambiguous.

But is economy really a science? Does the present crisis not demonstrate that, as one of the participants put it: "No one really knows what to do"? The reason is that expectations are part of the game: how the market will react depends not only on how much the people trust the interventions, but even more on how much they think others will trust them — one cannot take into account the effects of one's own interventions. While Sorman admits that market is full of irrational behavior and reactions, his medicament is — not even psychology, but — "neuroeconomics": "economic actors tend to behave both rationally and irrationally. Laboratory work has demonstrated that one

part of our brain bears blame for many of our economically mistaken short-term decisions, while another is responsible for decisions that make economic sense, usually taking a longer view. Just as the state protects us from Akerlof's asymmetry by forbidding insider trading, should it also protect us from our own irrational impulses?" Of course, Sorman is quick to add that "it would be preposterous to use behavioral economics to justify restoring excessive state regulations. After all, the state is no more rational than the individual, and its actions can have enormously destructive consequences. Neuroeconomics should encourage us to make markets more transparent, not more regulated."

With this happy twin-rule of economic science supplemented by neuroeconomics, gone are then the times of ideological dreams masked as science, as it was the case of Marx whose work "can be described as a materialist rewriting of the Bible. With all persons present there, with proletariat in the role of Messiah. The ideological thought of the nineteenth century is without debate a materialized theology." But even if Marxism is dead, the naked emperor continues to haunt us with new clothes, the chief among them ecologism:

No ordinary rioters, the Greens are the priests of a new religion that puts nature above humankind. The ecology movement is not a nice peace-and-love lobby but a revolutionary force. Like many a modern day religion, its designated evils are ostensibly decried on the basis of scientific knowledge: global warming, species extinction, loss of biodiversity, superweeds. In fact, all these threats are figments of the Green imagination.

Greens borrow their vocabulary for science without availing themselves of its rationality.

Their method is not new; Marx and Engels also pretended to root their world vision in the science of their time, Darwinism.[6]

Sorman therefore accepts the claim of his friend Aznar that the ecological movement is the "Communism of the XXIst century":

It is certain that ecologism is a recreation of Communism, the actual anti-capitalism...However, its other half is composed of a quarter of pagan utopia, of the cult of nature, which is much earlier than Marxism, which is why ecologism is so strong in Germany with its naturalist and pagan tradition. Ecologism is thus an anti-Christian movement: nature has precedence over man. The last quarter is rational, there are true problems for which there are technical solutions.

Note the term "technical solutions": rational problems have technical solutions. (Again, a blatantly wrong claim: the confrontation with ecological problems demands choices and decisions — what to produce, what to consume, on what energy to rely — which ultimately concern the very way of life of a people; as such, they are not only not technical, but eminently political in the most radical sense of the fundamental social choices.) So no wonder that capitalism itself is presented in technical terms, not even as a science but simply as something that works: it needs no ideological justification, because its success itself is its sufficient justification — in this regard, capitalism "is the opposite of socialism, which has a manual":

Capitalism is a system which has no philosophical pretensions, which is not in search of happiness. The only thing it says is: "Well, this functions." And if people want to live better, it is preferable to use this mechanism, because it functions. The only criterion is efficiency.

This anti-ideological description is, of course, patently false: the very notion of capitalism as a neutral social mechanism is ideology (even utopian ideology) at its purest. The moment of truth in this description is nonetheless that, as Alain Badiou put it, capitalism is effectively not a civilization of its own, with its specific way of rendering life meaningful. Capitalism is the first socioeconomic order which detotalizes meaning: it is not global at the level of meaning (there is no global "capitalist world view," no "capitalist civilization" proper — the fundamental lesson of globalization is precisely that capitalism can accommodate itself to all civilizations, from Christian to Hindu and Buddhist); its global dimension can only be formulated at the level of truth — without meaning, as the "real" of the global market mechanism. The problem here is not, as Sorman claims, that reality is always imperfect, and that people always need to entertain dreams of impossible perfection. The problem is that of meaning, and it is here that religion is now reinventing its role, discovering its mission to guarantee a meaningful life to those who participate in the meaningless run of the capitalist mechanism. This is why Sorman's description of the fundamental difficulty of capitalist ideology is wrong:

From the intellectual and political standpoint, the great difficulty in administering a capitalist system is that it does not give rise to dreams: no one descends to the street to manifest in its favor. It is an economy which changed completely the human condition, which has saved humanity from misery, but no one is ready to convert himself into a martyr of this system. We should learn to deal with this paradox of a system which

nobody wants, and which nobody wants because it doesn't give rise to love, which is not enchanting, not a seducer.

This description is, again, patently not true: if there ever was a system, which enchanted its subjects with dreams (of freedom, of how your success depends on yourself, of luck around the corner, of unconstrained pleasures...), it is capitalism. The true problem lies elsewhere: how to keep people's faith in capitalism alive when the inexorable reality of a crisis brutally crushes these dreams? Here enters the need for a "mature" realistic pragmatism: one should heroically resist dreams of perfection and happiness and accept the bitter capitalist reality as the best possible (or the least bad) of all worlds. A compromise is necessary here, a combination of fighting utopian illusory expectations and giving people enough security to accept the system. Sorman is thus no market-liberal fundamentalist extremist — he proudly mentions that some orthodox followers of Milton Friedman accused him of being a Communist because of his (moderate) support of the welfare state:

There is no contradiction between State and economic liberalism; on the contrary, there is a complex alliance between the two. I think that the liberal society needs a well-fare state, first, with regard to intellectual legitimacy – people will accept the capitalist adventure if there is an indispensable minimum of social security. Above this, on a more mechanic level, if one wants the destructive creativity of capitalism to function, one has to administer it.

Rarely was the function of ideology described in clearer terms — to defend the existing system against any serious critique, legitimizing it as a direct expression of human nature:

An essential task of democratic governments and opinion makers when confronting economic cycles and political pressure is to secure and protect the system that has served humanity so well, and not to change it for the worse on the pretext of its imperfection. Still, this lesson is doubtless one of the hardest to translate into language that public opinion will accept. The best of all possible economic systems is indeed imperfect. Whatever the truths uncovered by economic science, the free market is finally only the reflection of human nature, itself hardly perfectible.

Such ideological legitimization also perfectly exemplifies Badiou's precise formula of the basic paradox of enemy propaganda: it fights something of which it is itself not aware, something for which it is structurally blind — not the actual counterforces (political opponents), but the possibility (the utopian revolutionary-emancipatory potential) which is immanent to

the situation:

The goal of all enemy propaganda is not to annihilate an existing force (this function is generally left to police forces), but rather to annihilate an unnoticed possibility of the situation. This possibility is also unnoticed by those who conduct this propaganda, since its features are to be simultaneously immanent to the situation and not to appear in it.[7]

This is why enemy propaganda against radical emancipatory politics is by definition cynical – not in the simple sense of not believing its own words, but at a much more basic level: it is cynical precisely and even more insofar as it does believe its own words, since its message is a resigned conviction that the world we live in, even if not the best of all possible worlds, is the least bad one, so that any radical change can only make it worse.

(As always in effective propaganda, this normalization can be combined without any problem with its opposite, reading the economic crisis in religious terms – Benedict XVI, always sharp, was expeditious in capitalizing on the financial crisis along these lines: "This proves that all is vanity, and only the word of God holds out!") Sorman's version is, of course, too brutal and open to be endorsed as hegemonic; it has something of the "over-identification," stating so openly the underlying premises that it is an embarrassment. Out of present crises, the vesion which is emerging as hegemonic is that of "socially responsible" eco-capitalism: while admitting that, in the past and present, capitalism was often over-exploitative and catastrophic, the claim is that one can already discern signs of the new orientation which is aware that the capitalist mobilization of a society's productive capacity can also be made to serve ecological goals, the struggle against poverty, etc. As a rule, this version is presented as part of the shift towards a new holistic post-materialist spiritual paradigm: in our era of the growing awareness of the unity of all life on the earth and of the common dangers we are all facing, a new approach is emerging which no longer opposes market and social responsibility – they can be reunited for mutual benefit. As Thomas Friedman put it, nobody has to be vile in order to do business; collaboration with and participation of the employees, dialogue with customers, respect for the environment, transparency of deals, are nowadays the keys to success. Capitalists should not be just machines for generating profits, their lives can have a deeper meaning. Their preferred motto is social responsibility and gratitude: they are the first to admit that society was incredibly good to them by allowing them to deploy their talents and amass wealth, so it is their duty to give something back to society and help people. After all, what is the point of their success, if not to help people? It is only this caring that makes business success worthwhile... The new ethos of global responsibility can thus put capitalism to work as the

most efficient instrument of the common good.

But was the financial meltdown of 2008 not a kind of ironic comment on the ideological nature of this dream of the spiritualized and socially responsible eco-capitalism? As we all know, on December 11, 2008, Bernard Madoff, a great investment manager and philanthropist from Wall Street, was arrested and charged with allegedly running a $50 billion "Ponzi scheme" (or pyramid scheme). Madoff's funds were supposed to be low-risk investments, reporting steady returns, usually gaining a percentage point or two a month. The funds' stated strategy was to buy large cap stocks and supplement those investments with related stock-option strategies. The combined investments were supposed to generate stable returns and also cap losses — what attracted new investors was the regularity of high returns, independent of the market fluctuations — the very feature that should have made his funds suspicious. Sometime in 2005 Madoff's investment-advisory business morphed into a Ponzi scheme, taking new money from investors to pay off existing clients who wanted to cash out. Madoff told senior employees of his firm that "it's all just one big lie" and that it was "basically, a giant Ponzi scheme," with estimated investor losses of about $50 billion. What makes this story so surprising are two features: first, how the basically simple and well-known strategy still worked in today's allegedly complex and controlled field of financial speculations; second, Madoff was not a marginal eccentric, but a figure from the very heart of the US financial establishment (NASDAQ), involved in numerous charitable activities. Is it not that the Madoff case presents us with a pure and extreme case of what caused the financial break-down? One has to ask here a naïve question: but didn't Madoff know that, in the long term, his scheme is bound to collapse? What force counteracted this obvious insight? Not Madoff's personal evil or irrationality, but a pressure, a drive, to go on, to expand the circulation in order to keep the machinery running, which is inscribed into the very system of capitalist relations — the temptation to "morph" legitimate business into a pyramid scheme is part of the very nature of the capitalist circulation. There is no exact point at which the Rubicon was crossed and the legitimate investment business "morphed" into an illegal pyramid scheme: the very dynamic of capitalism blurs the frontier between "legitimate" investment and "wild" speculation, because capitalist investment is in its very core a risked wager that the scheme will turn out to be profitable, an act of borrowing from the future. A sudden shift in uncontrollable circumstances can ruin a very "safe" investment — this is what the capitalist "risk" is about. This is the reality of the "postmodern" capitalism: the ruinous speculation rose to a much higher degree than it was even imaginable before.

The self-propelling circulation of the Capital thus remains more than ever

the ultimate Real of our lives, a beast that by definition cannot be controlled, since it itself controls our activity, making us blind for even the most obvious insights into the dangers we are courting. It is one big fetishist denial: "I know very well the risks I am courting, even the inevitability of the final collapse, but nonetheless...I can protract the collapse a little bit more, take a little bit greater risk, and so on indefinitely."

What is to be Done?

So where are we today, after the "obscure disaster" of 1989? As in 1922, the voices from below ring with malicious joy all around us: "Serves you right, lunatics who wanted to enforce their totalitarian vision on society!" Others try to conceal their malicious glee, they moan and raise their eyes to heaven in sorrow, as if to say: "It grieves us sorely to see our fears justified! How noble was your vision to create a just society! Our heart was beating with you, but our reason told us that your noble plans can finish only in misery and new unfreedoms!" While rejecting any compromise with these seductive voices, we definitely have to "begin from the beginning," i.e., not to "build further upon the foundations of the revolutionary epoch of the XXth century" (which lasted from 1917 to 1989 or, more precisely, 1968), but to "descend" to the starting point and choose a different path.

In the good old days of Really-Existing Socialism, a joke was popular among dissidents, used to illustrate the futility of their protests. In fifteenth-century Russia occupied by Mongols, a farmer and his wife walk along a dusty country road; a Mongol warrior on a horse stops at their side and tells the farmer that he will now rape his wife; he then adds: "But since there is a lot of dust on the ground, you should hold my testicles while I'm raping your wife, so that they will not get dirty!" After the Mongol finishes his job and rides away, the farmer starts to laugh and jump with joy; the surprised wife asks him: "How can you be jumping with joy when I was just brutally raped in your presence?" The farmer answers: "But I got him! His balls are full of dust!" This sad joke tells of the predicament of dissidents: they thought they were dealing serious blows to the party nomenclature, but all they were doing was getting a little bit of dust on the nomenclature's testicles, while the nomenclature went on raping the people...Is today's critical Left not in a similar position? Our task is to discover how to make a step further — our thesis II [editors' note: Marx's *Theses on Feuerbach*, 1845] should be: in our societies, critical Leftists have hitherto only dirtied with dust the balls of those in power, the point is to cut them off.

But how to do it? The big (defining) problem of Western Marxism was the one of the lacking revolutionary subject: how is it that the working class

does not complete the passage from in-itself to for-itself and constitute itself as a revolutionary agent? This problem provided the main *raison d'être* of its reference to psychoanalysis, which was evoked precisely to explain the unconscious libidinal mechanisms, which prevent the rise of class-consciousness inscribed into the very being (social situation) of the working class. In this way, the truth of the Marxist socioeconomic analysis was saved, there was no reason to give ground to the "revisionist" theories about the rise of the middle classes, etc. For this same reason, Western Marxism was also in a constant search for other social agents who could play the role of the revolutionary agent, as the understudy replacing the indisposed working class: Third World peasants, students and intellectuals, the excluded...

Therein resides the core of truth of Peter Sloterdijk's thesis, according to which the idea of Judgment Day when all the accumulated debts will be fully paid and an out-of-joint world will finally be set straight, is taken over in secularized form by the modern Leftist project, where the agent of judgment is no longer God, but the people. Leftist political movements are like "banks of rage": they collect rage-investments from people and promise them large-scale revenge, the re-establishment of global justice. Since, after the revolutionary explosion of rage, full satisfaction never takes place and an inequality and hierarchy re-emerge, there always arises a push for the second — true, integral — revolution, which will satisfy the disappointed and truly finish the emancipatory work. 1792 after 1789, October after February...The problem is simply that there is never enough rage-capital. This is why it is necessary to borrow from or combine with other rages: national or cultural. In Fascism, the national rage predominates; Mao's Communism mobilizes the rage of exploited poor farmers, not proletarians. In our own time, when this global rage has exhausted its potential, two main forms of rage remain: Islam (the rage of the victims of capitalist globalization) plus "irrational" youth outbursts, to which one should add Latino American populism, ecologists, anti-consumerists, and other forms of anti-globalist resentment: the Porto Alegre Movement failed to establish itself as a global bank for this rage, since it lacked a positive alternate vision.

Today, one should shift this perspective totally, and break the circle of such patient waiting for the unpredictable opportunity of a social disintegration opening up a brief chance of grabbing power. Maybe, just maybe, this desperate awaiting and search for the revolutionary agent is the form of appearance of its very opposite, the fear of finding it, of seeing it where it already budges. There is thus only one correct answer to Leftist intellectuals desperately awaiting the arrival of a new revolutionary agent which will perform the long-expected radical social transformation — the old Hopi saying with a wonderful Hegelian dialectical twist from substance to

subject: "We are the ones we have been waiting for."[8] Waiting for another to do the job for us is a way of rationalizing our inactivity. It is against this background that one should reassert the Communist idea — a quote from Badiou:

The communist hypothesis remains the good one, I do not see any other. If we have to abandon this hypothesis, then it is no longer worth doing anything at all in the field of collective action. Without the horizon of communism, without this Idea, there is nothing in the historical and political becoming of any interest to a philosopher. Let everyone bother about his own affairs, and let us stop talking about it. In this case, the rat-man is right, as is, by the way, the case with some ex-communists who are either avid of their rents or who lost courage. However, to hold on to the Idea, to the existence of this hypothesis, does not mean that we should retain its first form of presentation, which was centered on property and State. In fact, what is imposed on us as a task, even as a philosophical obligation, is to help a new mode of existence of the hypothesis to deploy itself. [9]

One should be careful not to read these lines in a Kantian way, conceiving Communism as a "regulative Idea," thereby resuscitating the specter of "ethical socialism" with equality as its a priori norm-axiom...One should maintain the precise reference to a set of social antagonism(s), which generate the need for Communism — good old Marx's notion of Communism not as an ideal, but as a movement, which reacts to actual social antagonisms, is still fully relevant. If we conceive Communism as an "eternal Idea," this implies that the situation which generates it is no less eternal, that the antagonism to which Communism reacts will always be here — and from here, it is only one step to a "deconstructive" reading of Communism as a dream of presence, of abolishing all alienating re-presentation, a dream which thrives on its own impossibility.

So which are the antagonisms, which continue to generate the Communist Idea?

Where are we to look for this Idea's new mode? It is easy to make fun of Fukuyama's notion of the End of History, but the majority today is Fukuyamaist: liberal-democratic capitalism is accepted as the finally-found formula of the best possible society, all one can do is to render it more just, tolerant, etc. Here is what recently happened to Marco Cicala, an Italian journalist: when, in an article, he once used the word "capitalism," the editor asked him if the use of this term is really necessary — could he not replace it by a synonymous one, like "economy"? What better proof of the total triumph of capitalism than the virtual disappearance of the very term in the last two or three decades?

The simple but pertinent question arises here: but if alternatives to

liberal-democratic capitalism obviously work better than all known alternatives, if liberal-democratic capitalism is — if not the best, then at least — the least bad form of society, why should we not simply resign to it in a mature way, even accept it wholeheartedly? Why insist on the Communist Idea against all hopes? Is such an insistence not an exemplary case of the narcissism of the lost Cause? Does such a narcissism not underlie the predominant attitude of academic Leftists who expect from a Theoretician to tell them what to do — they desperately want to get engaged, but do not know how to do it efficiently, so they await the Answer from a Theoretician...Such an attitude is, of course, in itself a lie: as if the Theoretician will provide the magic formula, resolving the practical deadlock. The only correct answer here is: if you do not know what to do, then nobody can tell you, then the Cause is irremediably lost.

Again, it is thus not enough to remain faithful to the Communist Idea — one has to locate in historical reality antagonisms, which make this Idea a practical urgency. The only true question today is: do we endorse the predominant naturalization of capitalism, or does today's global capitalism contain strong enough antagonisms, which prevent its indefinite reproduction?

There are four such antagonisms: the looming threat of ecological catastrophe, the inappropriateness of private property for so-called "intellectual property," the socioethical implications of new techno-scientific developments (especially in biogenetics), and, last but not least, new forms of apartheid, new Walls and slums. There is a qualitative difference between the last feature, the gap that separates the Excluded from the Included, and the other three, which designate the domains of what Hardt and Negri call "commons," the shared substance of our social being whose privatization is a violent act which should also be resisted with violent means, if necessary: the commons of culture, the immediately socialized forms of "cognitive" capital, primarily language, our means of communication and education, but also the shared infrastructure of public transport, electricity, post, etc. (if Bill Gates were to be allowed monopoly, we would have reached the absurd situation in which a private individual would have literally owned the software texture of our basic network of communication); the commons of external nature threatened by pollution and exploitation (from oil to forests and natural habitat itself); the commons of internal nature (the biogenetic inheritance of humanity).

What all these struggles share is the awareness of the destructive potentials, up to the self-annihilation of humanity itself, if the capitalist logic of enclosing these commons is allowed a free run. Nicholas Stern was right to characterize the climate crisis as "the greatest market failure in human history." So when Kishan Khoday, a UN team leader, recently wrote:

"There is an increasing spirit of global environmental citizenship, a desire to address climate change as a matter of common concern of all humanity," one should give all the weight to the terms "global citizenship" and "common concern" — the need to establish a global political organization and engagement which, neutralizing and channeling market mechanisms, stands for a properly Communist perspective.

It is this reference to "commons" which justifies the resuscitation of the notion of Communism: it enables us to see the progressing "enclosure" of the commons as a process of proletarianization of those who are thereby excluded from their own substance, a proletarianization that also points towards exploitation. The task today is to renew the political economy of exploitation — say, of the anonymous "cognitive workers" by their companies.

It is, however, only the fourth antagonism, the reference to the Excluded that justifies the term "Communism." There is nothing more "private" than a State community, which perceives the Excluded as a threat and worries how to keep them at a proper distance. In other words, in the series of the four antagonisms, the one between the Included and the Excluded is the crucial one: without it, all others lose their subversive edge. Ecology turns into a problem of sustainable development, intellectual property into a complex legal challenge, biogenetics into an ethical issue. One can sincerely fight for ecology, defend a broader notion of intellectual property, oppose the copyrighting of genes, without confronting the antagonism between the Included and the Excluded — even more, one can even formulate some of these struggles in the terms of the Included threatened by the polluting Excluded. In this way, we get no true universality, only "private" concerns in the Kantian sense of the term. Corporations like Whole Foods and Starbucks continue to enjoy favor among liberals even though they both engage in anti-union activities; the trick is that they sell products with a progressive spin: one buys coffee made with beans bought at above fair-market value, one drives a hybrid vehicle, one buys from companies that provide good benefits for their customers (according to the corporation's own standards), etc. In short, without the antagonism between the Included and the Excluded, we may well find ourselves in a world in which Bill Gates is the greatest humanitarian fighting against poverty and diseases, and Rupert Murdoch the greatest environmentalist mobilizing hundreds of millions through his media empire.

What one should add here, moving beyond Kant, is that there are social groups which, on account of their lacking a determinate place in the "private" order of social hierarchy, directly stand for universality; they are what Jacques Rancière called the "part of no-part" of the social body. All truly emancipatory politics is generated by the short circuit between the universal-

ity of the "public use of reason" and the universality of the "part of no-part" — this was already the Communist dream of the young Marx: to bring together the universality of philosophy with the universality of the proletariat. From Ancient Greece, we have a name for the intrusion of the Excluded into the sociopolitical space: democracy.

The predominant liberal notion of democracy also deals with those Excluded, but in a radically different mode: it focuses on their inclusion, on the inclusion of all minority voices. All positions should be heard, all interests taken into account, the human rights of everyone guaranteed, all ways of life, cultures and practices respected, etc. — the obsession of this democracy is the protection of all kinds of minorities: cultural, religious, sexual, etc. The formula of democracy is here: patient negotiation and compromise. What gets lost is the proletarian position, the position of universality embodied in the Excluded.

The new emancipatory politics will no longer be the act of a particular social agent, but an explosive combination of different agents. What unites us is that, in contrast to the classic image of proletarians who have "nothing to lose but their chains," we are in danger of losing ALL: the threat is that we will be reduced to abstract empty Cartesian subject deprived of all substantial content, dispossessed of our symbolic substance, with our genetic base manipulated, vegetating in an unlivable environment. This triple threat to our entire being make us all in a way all proletarians, reduced to "substanceless subjectivity," as Marx put it in *Grundrisse*. The figure of the "part of no-part" confronts us with the truth of our own position, and the ethicopolitical challenge is to recognize ourselves in this figure — in a way, we are all excluded, from nature as well as from our symbolic substance. Today, we are all potentially a HOMO SACER, and the only way to prevent actually becoming one is to act preventively.

Notes

1. This chapter first appeared in *Chicago Journals*. It is reprinted here with the kind permission of the author.
2. Joseph Stiglitz, "The Bush administration may rescue Wall Street, but what about the economy?," *Guardian*, September 30, 2008, p. 1.
3. "Imagining a G.M. bankruptcy," *New York Times*, December 2, 2008, *Deal Book* in Business section.
4. And do we not find echoes of the same position in today's discursive "anti-essentialist" historicism (from Ernesto Laclau to Judith Butler) which views every social-ideological entity as the product of a contingent discursive struggle for hegemony? As it was already noted by Fred Jameson, the universalized historicism has a strange ahistorical flavor: once we fully accept and practice the radical contingency of our identities, all authentic historical tension somehow evaporates in the endless performative games of an eternal present. There is a nice self-referential irony at work here: there is history only insofar as there persist remainders of "ahistorical" essentialism. This is why radical anti-essentialists have to deploy all their hermeneutic-deconstructive art to detect hidden traces of "essentialism" in what appears a postmodern "risk society" of contingencies – the moment they were to admit that we already live in an "anti-essentialist" society, they would have to confront the truly difficult question of the historical character of today's predominant radical historicism itself, i.e., the topic of this historicism as the ideological form of the "postmodern" global capitalism.
5. "Esta crisis sera bastante breve," entrevista a Guy Sorman, *Perfil*, Buenos Aires, 2 November 2008, pp. 38–43.
6. Guy Sorman, "Behold, our familiar cast of characters," *Wall Street Journal Europe*, July 20–21, 2001.
7. Alain Badiou, Seminar on Plato at the ENS, February 13, 2008 (unpublished).
8. A Hopi saying, quoted from Daniel Pinchbeck, 2012: *The Return of Quetzalcoatle*, New York: Tarcher Press, 2007, p. 394.
9. Alain Badiou, *De quoi Sarkozy est-il le nom?*, Paris: Lignes, 2007, p. 153.

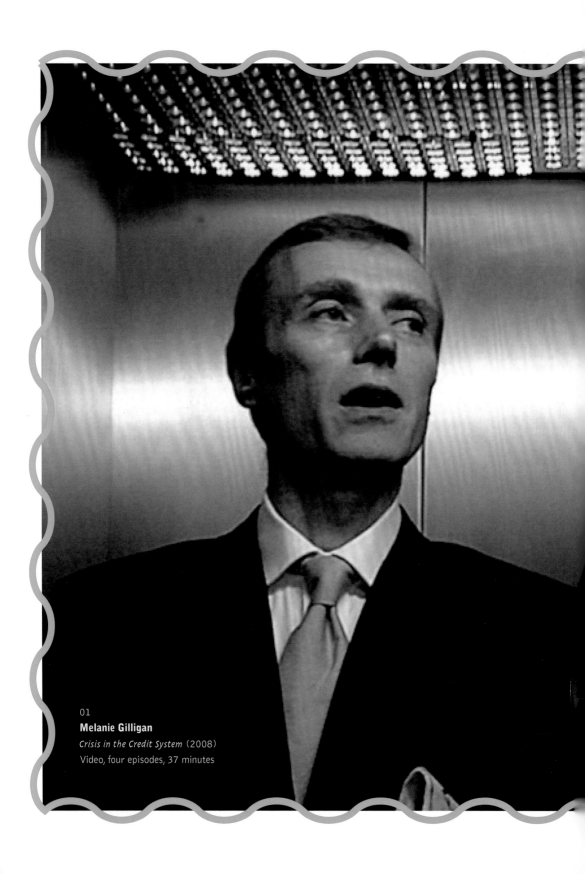

01
Melanie Gilligan
Crisis in the Credit System (2008)
Video, four episodes, 37 minutes

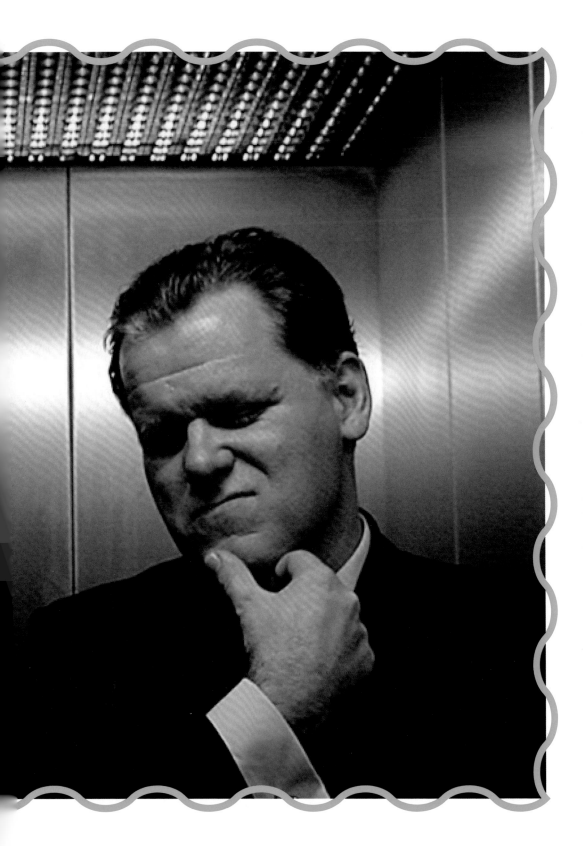

2a

Comments on Art from the Exhibition It's the Political Economy, Stupid

Liz Park

**Melanie Gilligan
Superflex
Isa Rosenberger
Libia Castro and Ólafur Ólafsson
Reading Lenin with Corporations
(Yevgeniy Fiks, Olga Kopenkina,
and Alexandra Lerman)
Institute for Wishful Thinking**

Crisis. This word has become ubiquitous since the worldwide recognition in 2008 of the fallibility of financial institutions previously believed to be "too big to fail." Marxist economist Andrew Kliman defines the term *crisis* not as *collapse*, nor as *slump*, but as "a rupture or disruption in the network of relationships that keep the economy operating in the normal way."[1] He argues, "[t]he present crisis is above all a *crisis of confidence*. To understand what this means we need to reflect on the fact that capitalism relies on credit, and the fact that the credit system is based on promises and faith."[2]

Under the circumstances, where can we, all of us who participate in this global economic system called capitalism, place our confidence? The US government bailout of banks was hard proof of the system's need to prop itself up despite its fundamentally crisis-prone nature. The system is based on a self-feeding mechanism with finite number of ways to prevent its ultimate collapse. **Melanie Gilligan** dissects this mechanism in her 2008 four-part fictional drama *Crisis in the Credit System*. With each scripted episode lasting about ten minutes, the narrative revolves around a group

of financial analysts, private fund managers, and derivative portfolio analysts who are participating in a workshop purportedly designed to equip them with "optimal adaptive strategies" in dangerous financial times. During the workshop, the participants are asked to imagine and act out extemporaneous skits based on various triggers. These role-playing sessions begin with a buzzing excitement as an analyst suggests that given the amount of trust issues today, the only way to profit would be to bet on the mood of the market by capturing people's distrust. She has even developed an "elegant" formula to capture distrust and claims it is foolproof. As the sessions progress, the application of this formula turns out to be nothing close to foolproof. The participants eventually come to liken the system to a circuitous machine that feeds the people who are then fed to the machine, creating a world divided between those who feed and those who are fed. "Until one day," a participant says, "they fed the machine to itself and they all died happily ever after." On this doomsday note, the workshop facilitator wraps up the sessions by handing out the participants' compensation packages for the lay-offs. The final episode ends with a pan of the finance workers, standing dumbfounded and unbelieving.

Gilligan's use of fiction reveals the highly plotted nature of the larger financial machination at work; as absurd and bizarre as the sessions may seem, they mirror, in essence, the sequence of events that led to the 2008 financial crisis. Toxic mortgage debt, derivatives used to mask this credit risk, and the intentional lack of federal regulation over

02
Superflex
The Financial Crisis (2009)
Video installation, 14 minutes

02

their trade – the financial instruments and activities that have come under scrutiny in light of the crisis, are mere symptoms, however. As Slavoj Žižek states in the essay included in this volume, "the main task of the ruling ideology in the present crisis is to impose a narrative which will not put the blame for the meltdown onto the global capitalist system AS SUCH, but on its secondary accidental deviation (too lax legal regulations, the consumption of big financial institutions, etc.)."[3]

Gilligan links this economic condition to the preponderance of artistic derivations in the current state of art production. She states: "it is likely that any art production today that could challenge these present circumstances will need to do so through a framework which addresses the self-cannibalization of culture today."[4] Consequently, Gilligan sets her plot deep in the heart of the financial world to build a counter-narrative aimed at the ideology that operates as described by Žižek.

While Gilligan uses fiction to turn our attention to the issue of confidence in today's political economy, **Superflex**'s 2009 *The Financial Crisis*, a series of four three-minute video hypnotherapy sessions, focuses on the psychological and emotional effects of the financial downturn experienced as a personal betrayal. Much different in tone and effect than Gilligan's, the film ostensibly proposes yet another way of dealing with the crisis. The hypnotist asks "you," the viewer and the patient, to imagine being in the position of: the invisible hand that corrects the market, in Session 1; George Soros, an expert stock trader also known as the man who single-handedly broke the Bank of England, in Session 2; and a laid-off worker who is about to lose everything, in Session 3. Finally, in Session 4, "you" are asked to enter your house, and in a room, discover your old friends Soros and the invisible hand. The last session wraps up with a goodbye to these old buds who had previously lent feelings of power, stability and control, but, in light of all that has happened, are no longer liked or wanted. The hypnotherapy ends at the snap of the fingers, at which the patient/viewer, the hypnotist claims, will wake up feeling happy, refreshed and comfortable despite the spiraling economy and the lost job and home.

The therapy sessions may seem tongue-in-cheek, but in both Gilligan's and Superflex's work, there is an ironic sense of optimism in the system's ultimate downfall. Returning to Kliman's definition, a crisis is a rupture,

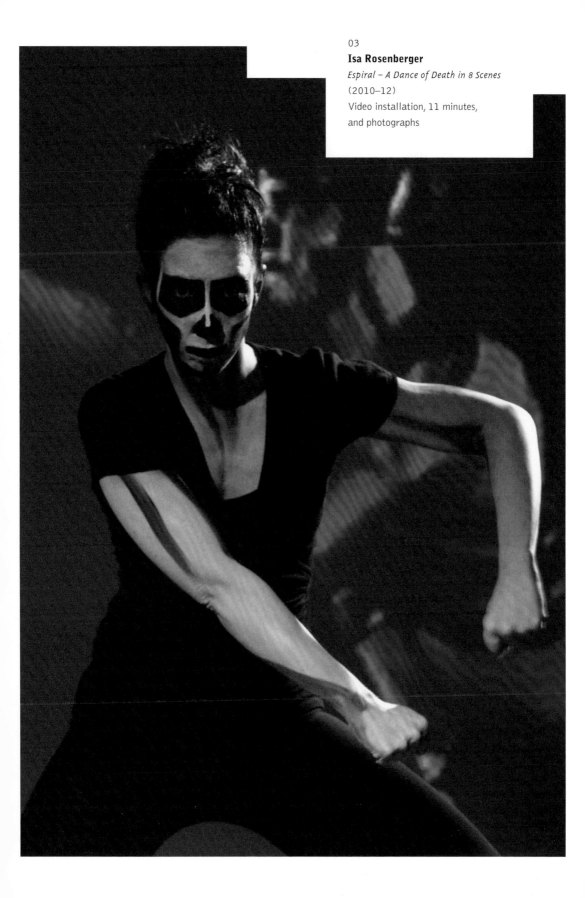

03
Isa Rosenberger
Espiral – A Dance of Death in 8 Scenes
(2010–12)
Video installation, 11 minutes,
and photographs

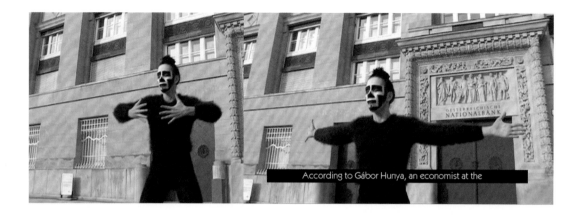

According to Gábor Hunya, an economist at the

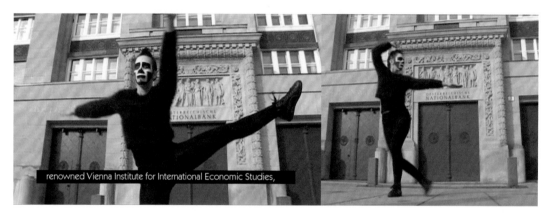

renowned Vienna Institute for International Economic Studies,

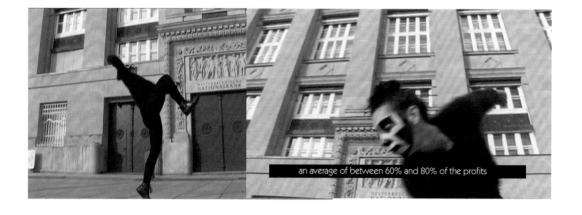

an average of between 60% and 80% of the profits

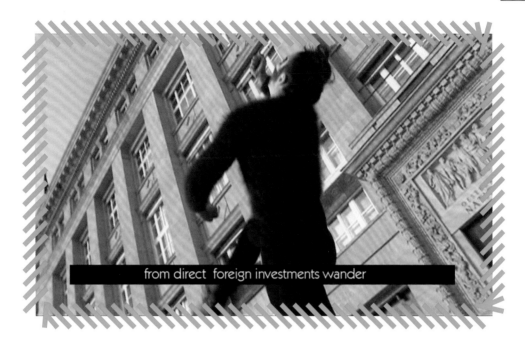

from direct foreign investments wander

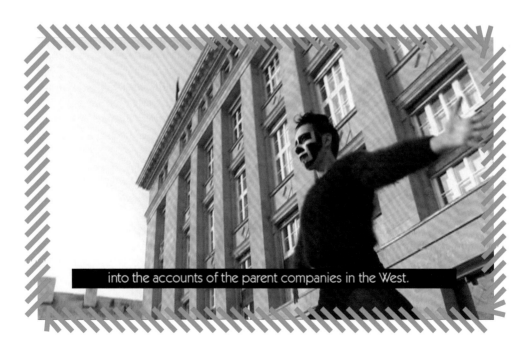

into the accounts of the parent companies in the West.

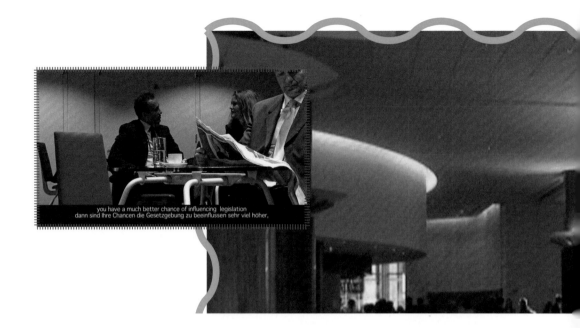

you have a much better chance of influencing legislation
dann sind Ihre Chancen die Gesetzgebung zu beeinflussen sehr viel höher,

a moment of possibility, and not of finality. Such moments warrant a measured analysis of the unfolding events of today and a critical reflection of the past histories. For **Isa Rosenberger**, the past comes colliding with the present in her 2010/12 three-part video *Espiral*. In a homage to Kurt Jooss's 1932 *The Green Table: A Dance of Death in 8 Scenes*, Rosenberger works with the Chilean dancer Amanda Piña to re-perform the sequence of Death in front of the Austrian National Bank. In the first section, Piña, made up as a skeleton, dances with stoicism and determination as scrolling text across the frame gives an account of the expansion of Austrian banks into the former Eastern Bloc in 2005. The text further explains how these newly created financial institutions send most of their profits back to parent companies in the West, leaving the new European Union entrants from the former Eastern Bloc mired in imbalanced power relations.[5] This tracing of Austria's eastward economic expansion matches the ominous tone of the dance of Death, who is twirling, flexing its muscles, and haunting the site of the country's financial heart. The next segment of the video shows a behind-the-scenes conversation between Piña and the artist, talking about Jooss's

legacy, and his work as an avant-garde choreographer and a social commentator in Weimar Germany. This discussion bridges Piña's dance in front of the National Bank in 2010 with the third segment, comprised of an excerpt from the 1932 staging of the ballet. Again, scrolling text provides financial context, but this time, of the Weimar Republic. The text begins with the 1931 bankruptcy of the Wiener Creditanstalt, the largest bank in Central and Eastern Europe. This event was considered to have been the trigger for the European banking crisis of 1931/32. The 1932 performance of *The Green Table* links this economic crisis to the rise of political turmoil in Europe, including the ascendancy of the Nazi party. In the performance, men in black suits, representing diplomats and politicians, literally and figuratively dance around the table, as Death relentlessly marches in its place in the background. The video ends with an epilogue from January 2012, citing the plummeting shares of UniCredit, an Italian company that has inherited much of Creditanstalt's shares. Soon after, the text explains, Western European banks began pulling out of Eastern Europe. In the background, Piña practices her steps as the dance of Death from 1932 is projected onto her body in a spatiotemporal collapse of two

04
Ólafur Ólafsson and Libia Castro
Lobbyists (2009)
Video, 16 minutes

parallel worlds at a moment of crisis.

A sense of urgency is evident in her work as well as in **Libia Castro and Ólafur Ólafsson**'s *Lobbyists*. This 16-minute experimental documentary-cum-music video from 2009 is the collective effort of British reporter Tamasin Cave who wrote the text, British actress Caroline Dalton who narrated, and Icelandic reggae group Hjálmar who performed the text as the soundtrack. This humorous and sometimes discordant form of narration explores the incongruous world of lobbyists in Brussels, the site of the European Parliament. The ballad covers a range of information about the politics of lobbying, including a billion euros spent on lobbying in the European Parliament annually to sway the opinions of the policy makers, and the creation of a voluntary register of lobbyists, an oxymoron that only points to the perfunctory attempt at transparency and accountability. However, what becomes obvious from the video is the heterogeneity of the 15,000 lobbyists in

Brussels, who reflect the interest of a range of clients including law firms, trade unions, NGOs, and corporations on topics such as climate change, regulation of the financial sector, and the fight against genetically modified foods. As stated in the artists' interview with Erik Wesselius of Corporate Europe Observatory, a Dutch organization dedicated to exposing the privileged access corporations and their lobby groups have to parliamentary procedures, "This is not about the actions of a private person. Lobbyists are clearly a very significant actor in the whole political process in Brussels. These actors are more or less invisible. That's unacceptable in a democracy."

From Žižek's definition of democracy as "the intrusion of the Excluded into the sociopolitical space,"[6] to Chantal Mouffe's advocacy for an agonistic space of political conflict,[7] the importance of expressing different political positions, Wesselius would agree, is critical in the counter-hegemonic struggles against the economic system that has

04

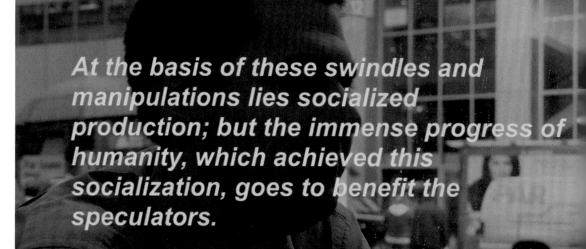

At the basis of these swindles and manipulations lies socialized production; but the immense progress of humanity, which achieved this socialization, goes to benefit the speculators.

V.I.Lenin, *Imperialism, the Highest Stage of Capitalism.* P.27

05
**Yevgeniy Fiks, Olga Kopenkina, and
Alexandra Lerman**
Reading Lenin with Corporations (2011/12)
Video, 60 minutes

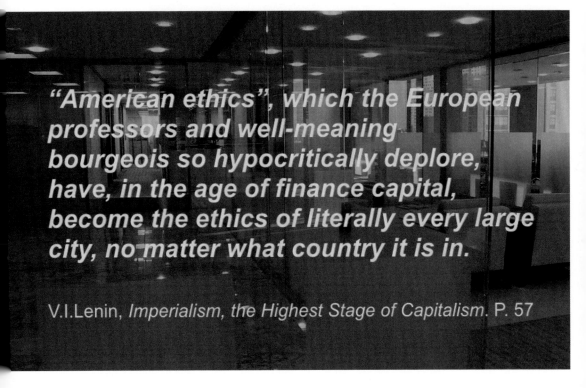

"American ethics", which the European professors and well-meaning bourgeois so hypocritically deplore, have, in the age of finance capital, become the ethics of literally every large city, no matter what country it is in.

V.I.Lenin, *Imperialism, the Highest Stage of Capitalism.* P. 57

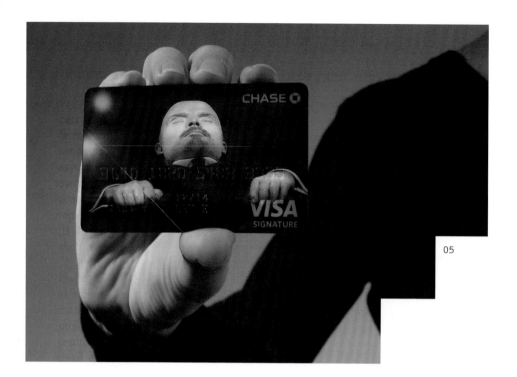

05

been eroding living wages and the necessary conditions of social reproduction. Reading Lenin with Corporations' (**Yevgeniy Fiks, Olga Kopenkina, and Alexandra Lerman**) 2011/12 video, *Reading Lenin with Corporations*, can be considered an exercise in creating a Mouffian space of agonism.[8] Initially conceptualized by Fiks in 2008, and produced in collaboration with Olga Kopenkina and Alexandra Lerman, this project invited employees of major corporations to partake in a reading seminar on Vladimir I. Lenin's text *Imperialism, the Highest Stage of Capitalism*. The seminars were held weekly between September and October 2008, just as the financial crisis unfolded in the midst of the American presidential election campaign. By contrast, their latest project was produced as Occupy Wall Street played out in downtown Manhattan. Made specifically for *It's the Political Economy, Stupid*, the video consists of interviews about the crisis with economic experts who have Wall Street corporate affiliations; however, most of the Russian-born trio's questions are based on Lenin's seminal book. The work opens up a space where dissensus, as opposed to consensus, can be fomented. While the ideals of a revolutionary political leader with a communist vision from

the beginning of the twentieth century and that of multinational corporations of the twenty-first century are incommensurable, this sort of pairing, according to Mouffe, "makes visible what the dominant consensus tends to obscure and obliterate."[9] The polyphony that results offers a rare opportunity to articulate and challenge divergent views in discussing the current state of the political economy.

The Institute for Wishful Thinking (IWT) is a collection of artists who share similar aims and approaches.[10] Founded in 2008, IWT invites on an ongoing basis proposals from artists, architects and designers for a residency at a US government agency or organization. This open-ended invitation and the proposals they have received to date – ranging from marking underground nuclear test sites to revising the classification system of public libraries – speak to the desire of creative people to reimagine a space for democratic participation and to engage in charting out the policies and actions that directly affect the citizens of the state. This motivation also drives their latest project, *Post-Fordist Variations* from 2011. IWT looks back in time to the 1970s when President Gerald Ford refused assistance to a then bankrupt New York City

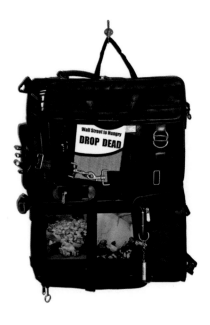

06
Institute for Wishful Thinking (IWT)
Post-Fordist Variations (2011)
Mixed media
IWT Installation View at the ACFNY
Photo: David Plakke

until the municipality cut spending on its social infrastructure. The beginning of neoliberal deregulation of economics, this moment is scrutinized by a group of artists associated with IWT. Taking the headline "Ford to City: Drop Dead" from the October 25, 1975, issue of the *New York Daily News*, these artists created variations of the front page – from Karl Lorak's alternate printing plate, to Nathania Rubin and The Jowl Brigade's animation of Ford's face morphing into key players in the development of neoliberalism such as Ronald Reagan and Margaret Thatcher, to Maureen Connor's newsprint illustrating how to make a Millwall brick, an improvised weapon made from a rolled-up newspaper. Not unlike Rosenberger, these variations look to history and critical moments in the development of capitalism to help trace the root of the crisis today. The title *Post-Fordist Variations* adds another temporal layer by referring to the automobile magnate Henry Ford. His deployment of the assembly line in factories at the beginning of the twentieth century drastically changed the way laborers fit into the capitalist equations of productivity and profit.

With a huge surplus of deskilled laborers and a demand for ever-more specialized labor forces in the post-Fordist economy, the current conditions for wage-earners can be described in no other terms than precarious. Critic and writer John Roberts explores what this means for art, and emphasizes the need to examine where art fits in the capital-labor relation. In "The Political Economization of Art," included in this volume, Roberts argues, "there is no radicalization in art and culture without a reflection on the part of artists and their audience on the material conditions of artistic production."[11] Whether it is through hypnotherapy, fiction, dance, music video, an unlikely reading group, or a revisit of an old newspaper, the artists discussed here begin from the material conditions that inform their lives as well as the shape and the content of their work. These artworks are driven by a sense of urgency in response to the crisis that we witnessed. Not wanting to miss that moment, they open up room for analysis, creative expressions, and action.

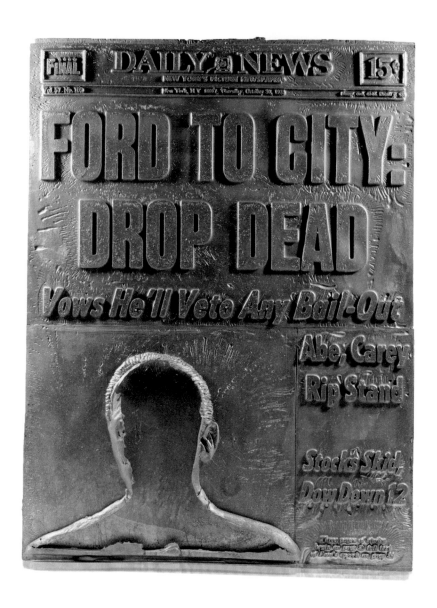

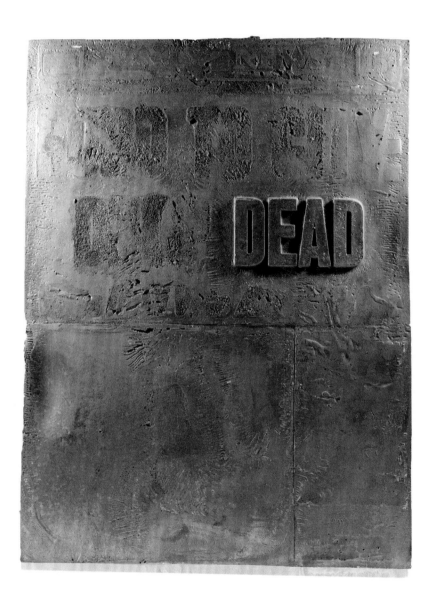

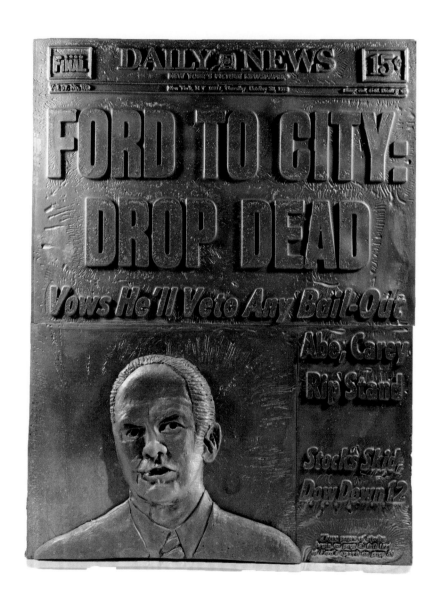

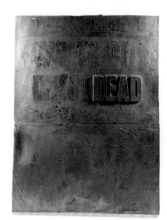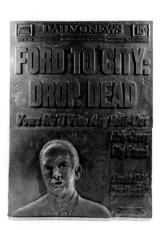

 FINAL **DAILY NEWS** **15¢**

NEW YORK'S PICTURE NEWSPAPER®

Vol. 57. No. 109 New York, N.Y. 10017. Monday, January 23rd, 2012 Sunny, cool, 47-55. Details p. 135

FORDists TO preCarITY: GET A GRIP!

Notes

1. Andrew Kliman, "A Crisis for the Centre of the System," *International Socialism*, no. 120, October 2008, http://www.isj.org. uk/?id=482.

2. Ibid.

3. Slavoj Žižek, "It's the Political Economy, Stupid!," in Gregory Sholette and Oliver Ressler, eds., *It's the Political Economy, Stupid*, London: Pluto Press, 2013, p. 17.

4. Melanie Gilligan, "Derivative Days: Notes on Art, Finance, and the Unproductive Forces," in Sholette and Ressler, *It's the Political Economy, Stupid*, p. 81.

5. This eastward expansion of Austrian banks can be considered an example of primitive accumulation. In Melanie Gilligan's chapter "Derivative Days: Notes on Art, Finance, and the Unproductive Forces," included in this volume and originally published in the March 2008 issue of *Texte zur Kunst*, she quotes Marxist writer and activist Loren Goldner to explain primitive accumulation as "accumulation that violates the capitalist 'law of value' which amounts to the 'exchange of non-equivalents.'" In Goldner's own words: "When Western capital sucks Third World labor power, whose costs of reproduction it did not pay for, into the world division of labor, whether in Indonesia or in Los Angeles, that's primitive accumulation. When capital loots the natural environment and does not pay the replacement costs for that damage, that's primitive accumulation. When capital runs capital plant and infrastructure into the ground (the story of much of the U.S. and the U.K. economies since the 1960s), that's primitive accumulation. When capital pays workers non-reproductive wages (wages too low to produce a new generation of workers), that's primitive accumulation too."

6. Žižek, "It's the Political Economy, Stupid!," p. 30.

7. For an elaboration of this concept, see Chantal Mouffe, *On the Political*, Abingdon, New York: Routledge, 2005.

8. While I recognize and appreciate the need for Mouffe's line of argument as a valid antithesis to radical violent resistance, I would like to note that there are important critiques of Mouffe's concept of agonism. Political scientist Jakeet Singh's panel presentation "Radical Democracy Goes Global: A Postcolonial Critique of Mouffe" at the 2011 Radical Democracy Conference provides an analysis of Mouffe's

concept of radical democracy as an imminent critique of liberal democratic norms, but one that does not recognize the complicity of liberal democracy with imperial democracy and its subalternizing effects. http://www.radicaldemocracy.org/2011/05/. More specifically related to how Mouffe's concept is taken up in art, especially by critic Claire Bishop, see Grant Kester, "The Sound of Breaking Glass, Part II: Agonism and the Taming of Dissent," *E-Flux Journal*, no. 31, January 2012, http://www.e-flux.com/journal/the-sound-of-breaking-glass-part-ii-agonism-and-the-taming-of-dissent/.

9. Chantal Mouffe, "Art and Democracy: Art as an Agonistic Intervention in Public Space," *Open*, no. 14, 2008, p. 12.

10. The members are Andrea DeFelice, Bibi Calderaro, Greg Sholette, John Pavlou, Matt Mahler, Maureen Connor, Nathania Rubin, Susan Kirby, and Tommy Mintz. As self-declared "Artists in Residence" for the US government, the IWT believes that the community of artists and designers possesses untapped creative and conceptual resources that could be applied to solving social problems. The IWT has responded to the latest economic disaster by collectively re-envisioning an iconic image from the last fiscal crisis. In the mid 1970s the US federal government initially refused to assist a then bankrupt New York City until austerity measures were put in place severely curbing spending on public schools, hospitals, libraries, and public transportation. Many see President Gerald Ford's decision as a punishing first step towards the adoption of neoliberalism, the radically deregulated economic model responsible for the global financial meltdown of 2008. Wishing artists and policy makers more, rather than less wishful historical thinking, the IWT's agents offer *Post-Fordist Variations*, a suite of substitute mementos based on the infamous October 25, 1975, *New York Daily News* headline: "Ford to City: Drop Dead."

11. John Roberts, "The Political Economization of Art," in Sholette and Ressler, *It's the Political Economy, Stupid*, p. 67.

The Political Economisation of Art[1]

3

John Roberts

Over the last ten years we have become witness to an extraordinary assimilation of art theory and practice into the categories of labor and production.

I say extraordinary because since 1945, and certainly since the rise of postmodernism in the late 1970s, the discourse on artistic labor and the labor theory of culture had fallen into abeyance. The new art history, the new cultural studies, and the revival of a Kantian-inspired philosophical aesthetics, had little or no interest in how and under what conditions artists labor, and the relations between artistic labor and productive labor generally. It was perhaps only Theodor Adorno, principally in *Aesthetic Theory* (1970) that remained committed to some version of the labor theory of culture, but even for Adorno, this commitment was less about unpacking the historic relations between artistic labor and productive and non-productive labor than fetishizing artistic labor as the ideal horizon of all labor. Art and production were, empirically at least, kept apart. Today, though, the theorization of the making and distribution of art are addressed explicitly in relation to the categories of political economy: value-form, labor-power, productive labor, non-productive labor, immaterial labor, the collective intellect and general intellect. Thus, this discourse is not focused simply on the market exchange of the artwork as commodity, but on what kind of commodities are the labor of the artist and the artwork. Or more precisely: how do artists labor, and what becomes of the value they create? Hitherto, such questions had been hidden behind the standard view that artists' labor is "free labor" brought to the market as a commodity for exchange — artist and artwork existing in an autonomous dyadic relationship. The break with this reified model of artistic labor, then, has become the radical standard bearer for a renewed relationship with the inter-relational functions of artistic and non-artistic labor, derived largely from the historic avant-garde's critique of art's place in the social and technical division of labor. In what ways does artistic labor resist or reinforce the capitalist division of labor? In what ways does artistic labor contribute directly or indirectly to the production of value, to the value form? In what ways, precisely, is the artwork a commodity? But how is this wide change in approach possible? What changes to art and labor have brought about this theoretical expansion of art into the categories of political economy?

The reasons are neither hard to find nor to fathom. Firstly, we are in the midst of a long and ongoing decline in capitalist profit — of which the recent banking crisis is an expression and symptom — that has its origins in the end of the post-war boom 1970s (profit levels have not recovered to these previous levels); and secondly, as a correlative of this long, attenuated crisis in production, we have also been witness to extended crisis in social reproduction, or non-reproduction: stagnation of wage levels; vast and increased global unemployment (the increase of what Marx called superfluous populations); destruction and privatization of the commons; labor precarity (the moving in and out of waged labor); the uncoupling of wage struggles and other labor struggles from even modest reformist challenges to the system.

In short, the system palpably is in decline — or a state of decadence, as Loren Goldner has called it — in a way that has not been visible since the 1930s. It is not surprising, therefore, that artists, have directed their attentions, then, to both the conditions of their own labor — its similarity with or distance from productive labor — but also, to the ways in which they might find a productive and critical place within this systemic crisis and within the ongoing crisis of the labor-capital relation — hence the exponential rise over the last ten years of participatory, relational and other socially-oriented practices, and in socialized art theory; for instance, Nicholas Bourriaud's *Relational Aesthetics* (1998) and *Postproduction* (2002), Grant Kester's *Conversation Pieces: Community + Communication in Modern Art* (2004), Gerald Raunig's *Art and Revolution* (2007), Greg Sholette's *Dark Matter* (2010), the writings of Chto Delat, the collection *Are You Working Too Much? Post-Fordism, Precarity and the Labor of Art* (2011), Gail Day's *Dialectical Passions: Negation in Postwar Art Theory* (2011) and Marc James Léger's *Brave New Avant-Garde* (2012). All this writing, of course, works with very different artistic and critical materials, and operates within very different political and philosophical traditions (Bourriaud: post-Situationism; Kester: a Laclau-Mouffe counter-hegemony; Raunig: a Deleuzian transversality; Sholette: tactical media; Chto Delat: Rancière and the politics of artistic autonomy; the authors of *Are You Working Too Much?*: Maurizio Lazzarato and the tradition of immaterial labor theory; Day: Hegelian-Marxism; Léger: Žižek's Lacano-Marxism), but they all share a sense that art and the artist are in a very different place than hitherto (modernism, postmodernism), and that this derives from how artists might distinguish what they do from what other workers do, in a world in which it is increasingly hard to separate artistic skills from non-artistic skills, artistic labor from non-artistic labor.

This dissolution and transfer of skills, of course, is none other than the question of labor's relationship to "general intellect" — derived from Marx's reflections in "The Fragment on Machines" in the *Grundrisse* on the increasing role of science and knowledge in the production process[2] — and which has become central to recent discussion of "cognitive capitalism," immaterial labor, profit-as-rent, and the general debate on artistic labor and immaterial labor. When artists and non-artists share similar tools, and procedures as laborers, then, to what extent are artists — in the collective sense — in possession of skills that are autonomous and non-transferable (the abiding assumption within traditional accounts of artistic creativity)? Artists and non-artists now share a continuum of skills derived from the presentational, archiving, and processing skills of the computer workstation. Now, this is not to reduce all artistic production to the kind of cognitive labor attached to office work but, rather, to recognize that image and text production and processing skills are one of the shared conditions of the expansion of the general intellect. Moreover, if artists and non-artists use similar techniques

and skills it is easy then for artists to be employed as "cognitive creatives/technicians" on many different kinds of projects, in the way a company might employ a freelance designer. In this sense, with the adaptation of these skills, the artist becomes a wage laborer as an artist, rather than working as a wage laborer in order to support their work as an artist (usually through teaching or, for an older generation, painting and decorating). One of the consequences of these changes is the social equalization of artistic skills and non-artistic skills. And it is on this basis that Negri and the post-workerist tradition (Maurizio Lazzarato, Christian Marazzi, Carlo Vercellone)[3] have talked generally about an immanent communization of labor in and outside of the workplace: the breakdown of the social division between the non-creativity of producers and the creativity of non-producers — a theme that has also been explored extensively in Ève Chiapello and Luc Boltanski's The New Spirit of Capitalism (2007). "A spontaneous and elementary form of communism," as Hardt and Negri put it, in Empire.[4]

The problems with this notion of communization are manifold, not least of all the failure of Negri and his post-workerist critics and followers to recognize how the equalization and cooperative content of these skills is merely formal in content. Far from being an indication of communization, it represents, on the one hand, the increasing subsumption of some sectors' "free artistic labor" to value production (for instance, in environmental regeneration or ecological projects; artists' material or ideational contribution to prestige architectural schemes or social housing projects) and, on the other, the increasing disciplinary capture of informational labor under a new (cognitive) technical division of labor. (The notion that communicative and informational labor harnesses the autonomy of artistic labor is only the case for a minority of cognitive workers.) Thus in keeping with the affirmation of living labor in workerism, post-workerism inflates the resistance of the worker at the expense of the heteronomous conditions of production as such. Yet, if this process of proto-communization is highly exaggerated, we are nevertheless witness to a series of art and labor couplings that have clearly shifted the cultural and political ground of artistic production. Quite simply, art today is subsumed under general social technique as a condition of art's increasing absorption into these new cognitive relations of production. The result is that the inexorable conceptualization of art since the 1960s has found a ready home within the new relations of production that even Walter Benjamin would have found remarkable. Thus it is the new conditions of artistic employability, unemployability, underemployment and precarity, which in many ways constitute the "social turn" in art over the last 15 years, rather than the emergence of any broad leftism within the art world per se. Or rather, a better way of putting it is: the present leftism of the current social turn is underwritten, shaped and driven by these new conditions of labor and

employability/unemployability. In this sense the crisis of the capital-labor relation has become a transformative and experimental space of opportunity for the new art, as more and more artists exist in the floating population of superfluous labor and are therefore superfluous not just to the labor market but to the prevailing conditions of artistic production itself. As a result, we see two major responses to this new space of artistic underemployment and unemployment (that is, lack of teaching; no sales; few exhibition possibilities): the transfer of post-conceptual artistic skills directly into the cultural service industries (regeneration schemes and non-artistic social projects generally), and the exponential rise in participatory, relational and other social forms of practice, that are either self-funded, or supported (and underfunded, of course) by public institutions. And this is why the issue of how artists labor, and the conditions under which they labor (and try to signify), has been the motor of the new radicalization. Consequently, when Gail Day argues in *Dialectical Passions* that there is a "new resistive potential,"[5] the emergence of a "new constellation of critical thought"[6] and a new sense of "anticipatory possibility"[7] in this new art, we need to bear this in mind, for there is no radicalization in art and culture without a reflection on the part of artists and their audience on the material conditions of artistic production. Thus, in light of the above, we need to unpack what this "anticipatory possibility" actually means.

What is increasingly evident about the current financial crisis is that it is not just a crisis of neoliberalism (the rise of fictitious capital), but of capitalist production as such. That is, the financial crisis is evidence of the relative stagnation of the system as a whole, which has its origins in the early 1970s, rather than the neoliberalism of the 1980s and 1990s. Before the early 1970s, the growth rate of the world's economies was reasonably stable. But from this date — that is, after the high point of the post-war boom in 1973 — there has been a general slowdown and then an increasing fall in the growth rate globally. For example, in the biggest economy, the US economy — a broad indicator of global tendencies — between 1957 and 1973 the growth rate averaged 57 percent; however, between 1975 and 2008 it had dropped to 30 percent. Similarly, the debt ratio of the US economy was largely stable between 1947 and 1981; in the next decades though, it rose rapidly from 150 percent in the early 1980s, to 274 percent in 2009. Also, the decline in state and infrastructure spending in the US began long before the rise of neoliberalism: the decline in the net stock of public sector structures (roads, public transport systems, the sewage system and water supplies, public utilities) actually started in 1968, 15 years before Reagan's attack on public spending. All these details (taken from Andrew Kliman's *The Failure of Capitalist Production*) then point to a crisis of profitability being in place before the rise of neoliberalism, that neoliberalism's debt-driven policies have in fact been designed to remedy or

ameliorate. Indeed, over the long haul, we see a steady decline in the rate of profit, with certain hikes in the level of general decline (as in the dot.com boom), which have been mistakenly confused with a return to pre-war levels of profitability.

Why has there has been decline in profits over the long haul? In order for capitalists to remain competitive (keep costs down; introduce new lines) they must either seek advantage through initiating technical and technological changes or keep up with these changes introduced by others — the alternative being, quite simply, going out of business. The outcome of this inter-firm competition is the continual rise in the technical and organic composition of capital (producing more with less living labor) — and in the current period, of course, this is exemplified by the introduction of new informational technologies into production. This produces a constant pressure on capitalists to replace machinery with new machinery that will enable them to continue to produce competitively, a process that Marx called "moral depreciation." In the current period, however, this process has speeded up (one generation of computer rapidly following another), increasing the "moral depreciation" of equipment before it is used up in production. Since the late 1970s, then, capitalists increasingly have had to depose of a larger share of their surplus value on their fixed assets as their equipment becomes obsolete in a shorter space of time. This in turn has created an additional pressure to further cut the labor force and the wage bill — ever present, of course.

The general effect of this process, therefore, is an increase in productivity at the expense of living labor. However, paradoxically, the increase in productivity produces a decline in wealth. With the loss of living labor there is loss in surplus value, generating an overproduction of goods chasing too few consumers, which in turn creates a loss of revenue. One of the effects of this, with the increasing expulsion of labor from production and the creation of a general population of precarious and underemployed laborers, is an uncoupling of wage struggles as a point of resistance to the system. In conditions of social non-production (stagnation of wage levels, destruction of the social wage and the commons, underemployment and unemployment) wage struggles have little mediatory effect on broader political questions: this is why lost days in strikes are so low (and anyway don't accumulate any political force in the long term) and why wage struggles are so atomized; wage struggles have no horizons beyond the maintenance of the status quo — and barely that. And this is why the traditional labor movement is in chronic abeyance, because wage struggles currently do not lead to any generalizable confrontation between labor and capital and the sharing out of social wealth — which, for all its limited political vantage point historically, was nonetheless a key part of the labor-capital relation and workers' identity under Fordism. Thus the idea that the best solution to the present crisis is a new Keynesian works program

— promulgated by many on the Left — fails to register the broader dynamic of non-reproduction as the overwhelming expression of the long-term fall in the rate of profit. Capitalism cannot return to full employment and to the expansion of workers' consumption, and therefore has radically diminished options. It can either maintain the current labor-capital arrangement (through various authoritarian programs, as it is trying to do presently) or it can renew the conditions for accumulation and increase in profit levels through the mass devalorization of capital. This is the more realistic solution for capital in the long term. But there are dangerous consequences to this option — this is why the last round of capital devaluation in the 1980s was relatively mild, and why the system is still in a debt-ridden suspensive state. To strip out capital from the system to the level it was in the late 1920s and early 1930s (closure of businesses and factories, withdrawal of credit, further running down of social services) is both to massively increase unemployment, but also to risk mass radicalization. As Andrew Kliman argues:

The amount of capital value that was destroyed during the Depression was far greater than advocates of laissez-faire policies had expected, and the persistence of severely depressed conditions led to significant radicalization of working people. Policy makers have not wanted this to happen again, so they now intervene with monetary and fiscal policies in order to prevent the full-scale destruction of capital value. This explains why subsequent downturns in the economy have not been as severe as the Depression.[8]

The other option — which fed the post-war boom — is world war. This more thorough "cleansing" of the system is clearly a last resort, but it is a resort, and an option that capital will take if it can unless labor intercedes against capital. Hence the underconsumptionist approach to the crisis (David Harvey, Dave McNally, Christian Marazzi, and others) — that more workers need to be put back to work in order to create more demand within the system — is misguided, for the assertion that this will restore workers' confidence in order to fight the system seems a strange inverted logic. It is one thing to defend the right of workers to receive a living wage, when and where possible; it is another to assume that the costs of non-reproduction can be miraculously dissolved by getting the system back to work — particularly when hundreds of millions are out of work globally. The present crisis is a crisis of labor, or the labor-capital relation itself.

One can see, therefore, why artistic labor has taken a radical social turn. It is actually doing some of the transformative, and political and creative work beyond the capital-labor relation, that the workers' movement, trade unions, and other official institutions of opposition are unwilling or incapable of doing. This is not to say the new social practices — whether community-

based, quasi-NGO initiatives, interdisciplinary schemes, radical art communes
— seek a classic substitutionalist political role for themselves, but rather that
this moment of social participatory activity is being driven by a counter-
political logic in which artistic thought-experiments, models of dissensus,
microtopian and utopian imaginings in artistic form, offer moments of what I
would call anti-capitalist socialization. This is why there is a current blurring
between artistic modes of action and activism and political action, as evident
in the revival of enclave thinking in the global Occupy movement. On this
basis, therefore, I think it is important to make a distinction in this current
period — as Théorie Communiste and Endnotes do — between socialization and
communization.[9] Socialization represents a space of negotiation within the
heteronomous conditions of capitalist relations. Communization represents
the disconnection or uncoupling of actions from the logic of capital itself. We
are presently not in the space of the latter, irrespective of what might be made,
in John Holloway's language, of building out from the "cracks" in capitalism,
or from Negri's model of proto-communization immanent to living labor.[10]

On the contrary, without the communization of labor — that is, the
withdrawal of labor from its self-identity as labor-power — communization is
simply another name for anti-capitalist socialization. What is emergent in this
current period of socialization, therefore, is an expanded prefigurative role of
art in the absence of any generalized actions by workers over and above the
terms of the labor-capital relation. That is, art's defense and articulation of
modes of autonomy and self-management become the productive language
of non-relation. But it is only when workers realize that there is no further
stake in the system for them (no more New Deals) that this initial and highly
limited process of the socialization of non-relation will then pass into a radical
mode of negation with capital itself. (This is why the struggle is not for the
socialization of the means of production: autonomy and self-management are
perfectly compatible with capitalism, and capital under New Deal conditions
will do its best to appropriate this language.) Indeed, this is visible already in
the kind of socialized capitalist thinking being pushed in *Wired* magazine and
other mouthpieces of the digital economy. As one recent commentator has put
it, what is required now post the "financial crisis" is a new form of capitalism,
"co-op capitalism."[11] Socialization, then, is the present horizon of the labor-
capital relation and of art/labor relations, not its revolutionary horizon.

It is not often that it can be said that the political stakes on writing on art
and politics are so high. But this is hard to avoid these days. Art-praxis has now
passed into a stage of primary convergence with political praxis, as a matter
of self-definition. That is, art-praxis has become crucial to a language of exit
from, and negation of, capital. Now, this is not to get ahead of ourselves; I
do not subscribe to the Capitalist Realist school of capitalist apocalypse;
nor do I believe, pace Slavoj Žižek, that we are living in "end times"; non-

reproduction, as a low-level authoritarianism, binding labor to capital in a grim dance, can roll on for a long time yet. But, nonetheless, in the long term the situation can only get worse, in which relative decadence will turn assuredly into absolute decadence. Hence non-reproduction is the prevailing context in which questions of art and politics — and non-relationality — will be fought over in the coming period. And therefore, for the first time — for a very long time — the terms of discussion will necessarily be shaped by the working out of how art might define itself in relation to labor, beyond socialization, as not-of-capital.

Notes

1. A version of this chapter was presented as a paper at Leeds University, February 29, 2012, as part of a discussion with Gail Day and Stewart Martin.
2. Karl Marx, *Grundrisse*, Harmondsworth: Penguin, 1970.
3. Maurizio Lazzarato, "Immaterial Labor," trans. by Paul Colilli and Ed Emery, http//www.generation-online.org/c/fcimmateriallabor3.htm; Carlo Vercellone, "From Formal Subsumption to General Intellect: Elements for a Marxist Reading of the Thesis of Cognitive Capitalism," *Historical Materialism*, no. 15, 2007, pp. 13–36; Christian Marazzi, *The Violence of Financial Capitalism*, trans. Kristina Lebedeva and Jason Francis McGimsey, Los Angeles: Semiotext(e), 2011; Christian Marazzi, *Capital and Affects: The Politics of the Language Economy*, trans. with an Introduction by Giuseppina Mecchia, Los Angeles: Semiotext(e), 2011.
4. Michael Hardt and Toni Negri, *Empire*, Cambridge, MA: Harvard University Press, 2000, p. 294.
5. Gail Day, *Dialectical Passions: Negation in Postwar Art Theory*, New York and Chichester: Columbia University Press, 2011, p. 22.
6. Ibid., p. 21.
7. Ibid., p. 232.
8. Andrew Kliman, *The Failure of Capitalist Production: Underlying Causes of the Great Recession*, London and New York: Pluto Press, 2012, p. 3.
9. See *SIC: International Journal of Communisation*, no. 1, 2011.
10. John Holloway, *Crack Capitalism*, London and New York: Pluto Press, 2010.
11. Noreena Hertz, "A Post-luxe Era Needs Co-op Capitalism," *Wired*, April 2012, p. 68.

Notes on Art,
Finance, and the
Unproductive
Forces[1]

4

Derivative
Days:

Melanie Gilligan

Modern art has evolved with
capitalism, always maintaining this
antinomy: that it is both like and
unlike a commodity.[2]

This development has taken a new turn today, when art, this singular type of commodity, has become financialized. It is now an increasingly popular asset class for financial investors who want to diversify their investment portfolios and is even traded by hedge funds. As a result, many sections of the art world have become more profit-driven; when something succeeds it does so increasingly through symbiosis with the market, and although such a situation may not seem new, overall this acceleration has brought about profound transformations in the way art is produced and disseminated as of late. Since the recent art market boom is, or was, a result of an immense expansion of the role of finance capital in the global economy, now that we are many months into a global credit crisis where the world's financial markets are contracting under the dead weight of previously unlimited credit expansion, the art world must hold its breath to find out what will happen next.

At the time of writing this chapter, Wall Street has recently bet on a 50 percent chance of a US recession, a development which by many accounts is already underway, while a recent Reuters article warns of the risk of a second Great Depression.[3] In the present era's post-Bretton Woods economic relativism (that is, with the controlled exchange rates of a gold–US dollar standard gone) we have seen an enormous expansion and recirculation of credit, for instance via leveraged investment (that is, investing with borrowed capital to increase returns), or through the securitization (that is, repackaging and trading) of all manner of debt, most infamously subprime mortgages whose losses were recently predicted to reach $400 billion by the G7 finance leaders.[4] The imprudent proliferation of such highly complex financial innovations has taken place off the balance sheet, in the ominously named "shadow banking system," utterly transforming the traditional banking system in the process. However, today a dearth of liquidity has dried out this network of leveraged trading channels and in so doing threatens to bring down the global economy. The ideal buoyant world where such repackaging of debt can go on ad infinitum has vanished, becoming one where trading debt is frightening (due to increased defaults on all kinds of debts caused by overextension of credit throughout the economy) and lenders back out. With the value of these traded debts undermined the intense complexity of such instruments has become a source of extreme anxiety since determining their value is often incredibly difficult. For instance, to accurately price one asset-backed security (ABS), rather than the general practice of relying on loose approximations it would take a specialist up to a week to assess its multiple variables.[5] As the outcomes of such staggering convolutions in debt trading shake up the global economy, the realm of derivative trading spreads risks around. Derivatives are financial instruments whose value is derived from the value of other things — often assets such as commodities, stocks, bonds, or they can be based on interest rates, exchange

rates, indexes, or even differentials in the shipping and freight industries and indexes of weather conditions. These generally take the form of contracts whereby different parties exchange risk, diminishing it for one while allowing the other to profit from it. To summarize, all of these innovations amount to a wildly expanding gap between surplus value produced in the economy and claims on wealth, and one might argue that this expansion both coincides with, and in many ways propels, today's widening economic gap between rich and poor.

These new involutions and complexities in financial markets surely increase economic abstraction but what exactly is becoming more abstract? Can it be assumed that such conditions somehow transfer to the sphere of culture at large and more specifically to art? The abstraction of exchange originates in the advent of money as a means of relating separate individual interests. Money evolves in order to enable the exchange of commodities and does so by effacing their particularity, replacing it with an abstract equivalence, and thus reconciling, or at least externalizing, the contradiction between a commodity's use-value (its particularity) and exchange-value (its generalization through exchange). However, even though money initially develops in order to serve this purpose, it acquires an independence, as Karl Marx says in the *Grundrisse*, "it is an inherent property of money to…achieve independence from commodities; to be a means which becomes an end;…to make exchange independent of the producers in the same measure as the producers become dependent on exchange."[6] Just as here, through money, commodity production for itself becomes commodity production for the sake of accumulation (that is, the hallmark of capital: value valorizing itself) through the growing power of the art market, art trading finds its own self-valorizing dynamic of exchange for accumulation's sake. Will a similar qualitative shift occur in art and its market as well, whereby art's commercialization, financialization and professionalization turn it into something else entirely? Or has it already happened? If so, what is this something else? In today's fragmented, globalized, and networked art world, for some the answer might be communication or knowledge which, like money, enables relations. With its ascendance as asset class, this other money-like aspect of art, emphasized in much art production of the past, seems to have come increasingly to the fore today. Yet, if the focus is often on transmission itself, what are the means through which this occurs?

To answer this question, let us start with a patent trend in art today: the tendency to burrow deeper and deeper into art's own history, conventions or conditions of production, often reiterating and performing them as increasingly emptied out. Much art today reconfigures, reuses, and repurposes past cultural signs, from within or outside the field of art, and this is nothing new by any means. Art, like many other fields of culture today, takes part in a wide array of historical recycling, interminably pushing this reuse to the nth

degree and, just when one thinks it can go no further, it continues unabated. This tendency has been discussed with great frequency as of late, for instance Nicolas Bourriaud dedicates much of his book *Postproduction* to describing it, stating that "the artistic question is no longer: 'what can we make that is new?' but 'how can we make do with what we have?'"[7] However, what is new about this lack of newness during the present moment is that today this type of appropriation can no longer be considered simply as a strategy (such as appropriation art in the 1970s and 1980s) because it has become such an entrenched common practice. Rita Ackermann references Hans Bellmer in her recent drawings, artists like Carol Bove or Steven Claydon mash together all manner of periods and references to earlier art or in a further turn, Pablo Bronstein brings postmodernist architecture's pastiche of earlier periods back into circulation. In his book *The Man Without Content*, Giorgio Agamben describes Hegel's reading of romantic aesthetics whereby the philosopher calls the self-reflexive and ironic appreciation of art as the content of art in modern aesthetic practice "negation that negates itself, a self-annihilating nothing,"[8] elsewhere bringing in a similar treatment to the equally ironic enjoyment of bad taste (and one could easily add to this list the popular practice of bringing back forms and styles that are outmoded). Yet it seems that such negations in aesthetic cultural practice often seem to extend art production ad infinitum much like those which expand the autonomy of exchange in finance as outlined above. These formal operations bear a striking similarity to financial derivatives in one particularly suggestive way: they derive their value from the value of something else. They depend on the reorganization of something already existing.

In order not to simply diagnose postmodernism all over again, we can update and differentiate today's condition by going directly to one of postmodernism's major theorists. In his text "Culture and Finance Capital," Fredric Jameson builds on his analysis of postmodern culture by examining the cultural products resulting from an era dominated by finance capital (written in 1996 when hallmarks of finance's current era such as hedge funds and derivatives really began to kick off). For Jameson, the real abstraction of capitalist exchange relations which pervaded all other social relations "had as one significant offshoot the emergence of modernism in the arts" whereby "modernism faithfully — even 'realistically' — reproduced and represented the increasing abstraction and deterritorialization" of capital.[9] However, he describes a marked difference today. Whereas the modernist avant-garde of the last century responded to a period of productivity in capitalism, our current economy is dominated less by production, and more by an intense expansion of finance capital. He calls this new set of conditions a moment when "capital itself becomes free-floating. It separates from the 'concrete context' of its productive geography. Money becomes in a second sense and to a

second degree abstract (it always was abstract in the first and basic sense)."[10]

It is worthwhile examining the last part of Jameson's conclusions here. Indeed, the evolution of more complex, convoluted, and fictitious values within finance immeasurably expands the autonomy of exchange, giving rise to a new agency for circulation that would make a modernist's jaw drop. Yet money's fundamental abstraction has not changed. All these recent innovations, these notional instruments for generating wealth, grossly abstract the correlation between money (in the form of contracts, other titles to wealth, and so on) and value, but money still remains a third term mediating commodity exchange. As Marx said, it is a characteristic of money "to be an inherent quality of commodities while it simultaneously exists outside them."[11] In other words, money is both a tradable commodity and the mediator of all commodities. Money's condition of being simultaneously like and unlike other commodities (in this respect, it resembles art, or rather vice versa) is magnified in finance capital: the medium of exchange becomes an object of exchange, the contemporary reflexive action par excellence. The modes in which money can be expanded, proliferated, stretched, and layered are what constitute the newest stages of abstraction in finance capital. To return to money's original task of reconciling capital's contradictions, Marx says that "the further development of the commodity" into commodity and money "does not abolish these contradictions but rather provides the form in which they have room to move."[12] Indeed, global banking systems, finance capital, and its multiplied forms of credit would all fall into that category. Capital's contradictions are repeated once again on the level of the financial system, in the gross discrepancies between titles to wealth and surplus value produced.

Returning to Jameson's argument, one notices that it echoes various statements by Theodor Adorno on the connection between the social forces of production and art, for instance when the Frankfurt School philosopher says:

Although it appears to be merely subjective, the totum of forces invested in the [art] work is the potential presence of the collective according to the level of the available productive forces: Windowless, it contains the monad...He embodies the social forces of production without necessarily being bound by the censorship dictated by the relations of production...[13]

For Adorno, the forces available to production in a given period, which include both social and intellectual resources as well, also produce art and as such, those conditions appear in artworks. Like Leibniz's monads, there is no direct communication, "the artist works as social agent" while remaining "indifferent to society's own consciousness."[14]

In such a spirit, Jameson surveys the pop cultural landscape in his particular time of finance capital and sees in popular culture (specifically works such

as Derek Jarman's *The Last of England*) a condensation of visual language predicated on the re-consumption of conventions and clichés. He sees reflexive aesthetic practices as obtaining a heightened abstraction corresponding to the ever-mounting abstraction of finance capital. For Jameson (here citing Giovanni Arrighi and Fernand Braudel) this expansion of finance signals capital's autumn (or at least one of them) whereby its prior productive expansion is drawing to a close, prompting capital flight of from the West;[15] however, the philosopher does not take these connections between finance and deindustrialization much further. This link is clarified by Marxist writer and activist Loren Goldner who sees the striking growth of finance capital, where immense profits are garnered through the reconfiguration of existing wealth, as achieved through capital's self-cannibalization of its prior productive expansion which he calls "a huge operation of credit pyramiding...aimed at preserving the paper value of existing titles to wealth, and a significant transfer of working class wages...to help prop up those titles."[16]

Here we begin to see that, beyond Jameson's argument, contemporary cultural practices also crystallize a wider economic and social condition of recursive reuse and repurposing which is coincident with the vertiginous complex configurations of exchange today. When we consider our present moment of finance capital we must keep in mind what accompanies this: decades of deindustrialization, privatization, and the constant devalorization of labor both in terms of real wages and the overall reproduction of workers' labor power (that is, through cuts to health care, pensions, rising costs of living and education), and overall neglect of those duties traditionally maintained by the state such as public infrastructure. In the US, the way in which the New Orleans working class was left to rot is one indefensible example of this latter phenomenon, along with countless others. The above is what Goldner describes as a condition in which capital no longer reproduces itself — that is, it is not paying the costs of its reproduction. This, Goldner says, amounts to a form of "primitive accumulation" or looting of the wealth that had in previous decades been invested in the forces of production.

In Goldner's own words:

When Western capital sucks Third World labor power, whose costs of reproduction it did not pay for, into the world division of labor, whether in Indonesia or in Los Angeles, that's primitive accumulation. When capital loots the natural environment and does not pay the replacement costs for that damage, that's primitive accumulation. When capital runs capital plant and infrastructure into the ground (the story of much of the U.S. and the U.K. economies since the 1960s), that's primitive accumulation. When capital pays workers non-reproductive wages (wages too low to produce a new generation

of workers), that's primitive accumulation too.[17]

I am not the first to draw these connections between capital's looting of the forces of production and art. Rather, I first encountered these ideas in conversations with writers Benedict Seymour and Daniel Berchenko whose discussions centered on synthesizing Goldner's perspective regarding capital's non-reproduction with an Adornian take on the productive forces in aesthetics.[18] By grasping the fact that the looting of the productive forces happens across the economy and also in art, we start to get a fuller picture of the connections between reuse and reflexivity in art, on the one hand, and the increased abstraction of finance capital, on the other. It all hinges on continuous looting and emptying out throughout many diverse spheres of the economy. Such strategies expand and continue art production while — as Marx said of money and was suggested of finance above — giving art's contradictions room to move, not least those regarding its relation to the commodity. As a means to make new cultural products, the looting of one's cultural resources tends to exploit differentials that develop from one social and historical context to another — for instance the way that performance art comes back when performance is becoming a ubiquitous social condition, or how social relations in general, and of art production in particular (that is, Reena Spaulings, Cosima von Bonin, and others), become another material on the artist's palette when those relations have been, and are continuously, transformed through increased commodification. Marxist philosopher Alfred Sohn-Rethel comments that for the duration of a commercial transaction a commodity must be assumed not to age or deteriorate materially and that this conceptual suspension in abstract timelessness and immutability facilitates the fixing of a value for the commodity. Such "exchange abstraction," as Sohn-Rethel calls it, notionally freezes a commodity within its moment of exchange,[19] and though the philosopher never discussed this, it follows that lags and differentials in time and place come about, allowing for the possibility of their profitable exploitation. In fact, these form the basis for many financial trading practices. For instance, arbitrage is the practice of taking advantage of a price differential between two or more markets. In the yen carry trade (whose recent unwinding coincided with the earliest signs of the subprime crisis), investors take advantage of low interest rates in Japan to purchase other currencies yielding a higher interest rate and thus benefit from the difference. Structured investment vehicles (SIVs) manage the differentials between long- and short-term securities. On the other hand, cultural recycling within and beyond art plays and capitalizes on historical differentials in the suspended exchange-time of styles, concepts, and trends because changes in context and period between the first time a cultural material makes its appearance and its later reanimation (that is, the effect of historical

distance) give those differentials value. Perhaps Adorno had an intimation of this when he said that "society 'appears' in art works...and is brought to a standstill in them."[20] One might argue that the very way in which past cultural products such as fashion items stand as a sign condensing the essence of a period attests to the fact that they represent not just a style but a frozen moment of exchange. It is even conceivable that were the social order not mediated through myriad exchange abstractions, in culture at large but also in art, there would be less necessity that everything must go out of style.

Jameson's notion of connecting such reflexive abstraction in art to finance can be developed by scrutinizing the financial practices themselves. While the trading of derivatives such as futures or credit default swaps allows investors to speculate on any type of eventuality, popular focus for such investment practices is betting on the movements of the market itself; that is, the potential ups and downs of various investments and market trends. In fact, in finance the indicators one uses to make investment decisions become themselves, through various instruments, objects of speculation. For instance, the VIX, known on Wall Street as the "fear index," is a measure of market volatility, of how investors will react, that in recent years has become something whose fluctuations can be bet on. It is effectively a way that the market profits from its own anxiety over profits, a means of 'playing chicken' with itself. Is this very different from a situation in which art, in dialogue with its own history and context, is increasingly looking to incorporate reflection on its own conditions into new production? A similar sort of reflexive bracketing happens when a contemporary artist says: "I am not making didactic or pedagogic art, I'm making work that reflects on its own didacticism." Or "I'm not simply painting, I'm making painting that through reiterating its conventions/history/presuppositions comments on/challenges those premises." Arguably, these types of operations bracket their object via the perception of a distance or disassociation in a similar way to the play of historical differentials inherent in cultural recycling. Perhaps this distance afforded by reflexive awareness is also influenced, to a certain degree, by practices of monetary exchange.

Much in the same way that a grappling with exchange abstraction can be seen in various modernist avant-garde works, we can see the present moment of capital in works such as artist favorite of hedge fund managers, Richard Prince's, reflexive cannibalization of his own joke paintings or Seth Price's reworking his previous videos, along with so many other examples in a similar vein. This goes beyond art practices that literally self-cannibalize, to the various manifestations of the imperative to continue art production through the reassessment, reuse, and repurposing of art qua art. For instance, Price's recent work seems to consciously emphasize such operations through using the stand-in of an internet image and performing multiple derivations

from it: discarding the picture's focus and concentrating on its negative spaces, then dilating it through a complex design process for the purposes of "fabrication of a 'look and feel' that had not previously existed" (as stated in the press material for Price's current show at Friedrich Petzel in New York). Yet so widespread are such examples that it seems almost superfluous to cite specific artists. As with cultural recycling, it seems almost to form the ground or precondition for making art today. Reflexive amplification through aesthetic qualities of wrongness, failure, and bad taste can all become ways to reconfigure and reshuffle what already exists.

Pointing to these connections between art strategies and the configuration of contemporary capital is not to designate such operations complicit with capital's logic. What is being discussed here is a prevalent condition of contemporary life, and so it is likely that any art production today that could challenge these present circumstances will need to do so through a framework which addresses the self-cannibalization of culture today. This is not a call for a return to productive economic expansion, nor is it an appeal for art that reflects this. It would be as ridiculous to think that capital could reverse its dependence on finance as it would be to think that what are needed today are art forms that are somehow "productive." Since there is nothing new about these aesthetic strategies we've discussed, and since in this time when nothing is new it is only the vast preponderance of such strategies which is novel, it is simply worthwhile to try to discern and reject the reactionary aspects of this "making do with what we have" aesthetic while finding ourselves in these conditions.

Notes

1. This chapter was originally published in a longer version for a special issue of the journal *Texte zur Kunst* dedicated to "Abstraktion." Consequently the reader will notice that throughout the text I repeatedly return to the concept of abstraction and how it might be conceived in the context of art's relation to finance. Also, it is important to be aware that the discussion of finance in this text was written at the very early stages of the economic crisis. After this point, the economic crisis worsened and the financial system changed in response. See "Derivative Days: Notes on Art, Finance, and the Unproductive Forces," *Texte zur Kunst*, no. 69, March 2008, pp. 146–53.
2. See Stewart Martin on Theodor Adorno's discussion of the relation between art and the commodity. Stewart Martin, "The absolute artwork meets the absolute commodity," *Radical Philosophy*, no. 146, November/December 2007, p. 18.
3. John Parry, "Depression risk might force U.S. to buy assets," Reuters, February 12, 2008, http://www.reuters.com/article/email/idUSGOR27660220080212?sp=true.
4. David Pilling, Jonathan Soble, and Gillian Tett, "Subprime credit losses forecast to reach $400bn by G7 leaders," *Financial Times*, February 11, 2008, p. 1.
5. John Dizard, "Useful strategy to take advantage of the Bear mess," *Financial Times*, July 10, 2007, http://www.ft.com/cms/s/0/4258d2f4-2e7d-11dc-821c-0000779fd2ac.html.
6. Karl Marx, *Grundrisse*, London: Penguin Books, 1973, p. 151.
7. Nicolas Bourriaud, *Postproduction*, Berlin and New York: Lukas & Sternberg, 2002.
8. Giorgio Agamben, *The Man Without Content*, Stanford: Stanford University Press, 1999, "On Bad Taste," pp. 18–20, "On Irony and Reflexivity," p. 55.
9. Fredric Jameson, "Culture and Finance Capital," in *The Cultural Turn*, London: Verso, 1996, p. 143.
10. Ibid., p. 142.
11. Marx, *Grundrisse*, p. 151.
12. Karl Marx, *Capital*, vol. 1, London: Penguin Books, 1990, p. 198.
13. Theodor Adorno, *Aesthetic Theory*, London: Athlone Press, 1997, p. 43.
14. Ibid.

15. Jameson, "Culture and Finance Capital," p. 142.

16. Loren Goldner, "Fictitious Capital for Beginners: Imperialism, 'Anti-Imperialism', and the Continuing Relevance of Rosa Luxemburg," *Mute*, vol. 2, no. 6, 2007, http://www.metamute.org/en/Fictitious-Capital-For-Beginners.

17. Ibid.

18. In his own writing, Benedict Seymour has commented that this condition of non-reproduction and repetition in art fits all too well with the economic instrumentalization of culture in the UK today under New Labour. Riffing on Marx's famous quote stating that "great world-historic facts and personages appear, so to speak, twice...the first time as tragedy, the second time as farce," Seymour asks: "are we witnessing a 'non-reproduction' of the avant-garde, in which the critical resources of modernism, tragically entangled with the mythologies of statist socialism and fascism the first time round, are today repeated in service of the post-Fordist farce?" Benedict Seymour, "Sport, Art and the Non-reproduction of Culture," *Mute*, vol. 2, no. 8, 2008. One might add that Adorno, who theorized that "the new" in art is a crucial quality which links the artwork and the commodity and exchange, wouldn't have anticipated how instead "make do with what we have" has become the battle-cry of contemporary neoliberalism.

19. Alfred Sohn-Rethel, *Intellectual and Manual Labour: A Critique of Epistemology*, London: Macmillan, 1978, p. 48; pp. 7, 25, and passim.

20. Theodor Adorno, *Aesthetic Theory*, p. 236, London: Athlone Press, 1997.

(5)

Occupational
Realism[1]

Julia Bryan-Wilson

In 1998, California-based artist Ben
Kinmont began his longest and most
involved conceptual project to date:
he opened his own bookselling business.

The piece, which is ongoing, is entitled *Sometimes a Nicer Sculpture is Being Able to Provide a Living for Your Family*, and Kinmont's use of the word "sculpture" harks back to Joseph Beuys's notion of "social sculpture" as "how we shape our thoughts into words...[and] how we mold and shape the world we live in."[2] Kinmont specializes in antiquarian books with a focus on gastronomy, and in this capacity attends auctions, participates in book fairs, works with libraries in need of development, logs his inventory, negotiates prices, and ships books to private and public collections around the world. *Sometimes a Nicer Sculpture* is meant to function both as an income-generating bookselling trade and a performance that is legible as such in the art world.

For Kinmont, it is important that his business function *as a business*; it is not enough for him to gesture symbolically towards the world of commerce by, say, printing up ironic letterheads or opening a fake storefront. As a result, he partakes in what I have termed "occupational realism," in which the realm of waged labor (undertaken to sustain oneself economically) and the realm of art (pursued, presumably, for reasons that might include financial gain, but that also exceed financialization and have aesthetic, personal, and/or political motivations) collapse, becoming indistinct or intentionally inverted. These are performances in which artists enact the normal, obligatory tasks of work under the highly elastic rubric of "art." Here, the job becomes the art and the art becomes the job.

"Performance as occupation" participates in the rising tide of discourse regarding the interconnection of contingent labor, artistic value, and precarity. Precarity is one name given to the effect of neoliberal economic conditions emergent in the wake of global financial upheaval, recession, and the reorganization of employment to accommodate the spread of service, information, and knowledge work. It designates a pervasively unpredictable terrain of employment within these conditions — work that is without health care benefits or other safety nets, underpaid, part-time, unprotected, short-term, unsustainable, risky.[3] Debates about precarity — and an insistence that artists belong to the newly emerging "precariat" — have been increasingly taken up within contemporary art, as evidenced by exhibitions such as *The Workers: Precarity/Invisibility/Mobility*, which opened in 2011 at the Massachusetts Museum of Contemporary Art, as well as anthologies like *Critique of Creativity: Precarity, Subjectivity, and Resistance in the "Creative Industries"* and *Are You Working Too Much?: Post-Fordism, Precarity, and the Labor of Art*.[4] A group of cultural and educational laborers in London organized themselves into the Precarious Workers Brigade, and they have mobilized to protest arts funding cuts in the UK, the economic and power dynamics of unpaid internships, and other issues; their posters ask questions such as "Do you freelance but don't feel free?"

The ascendance of the term "precarity" connects to research in the last

few years by sociologists such as Pascal Gielen, with his consideration of the congruence between artistic practices and post-Fordist economies.[5] But this alleged congruence has wider consequences, as it underscores the need to understand artistic occupations temporally. As Pierre-Michel Menger's 2006 report on artistic employment notes, "the gap is widening" between brief vocations and lifelong careers:

How do short-term assignments translate into worker flows and careers? From a labor supply standpoint, one artist equals one long-term occupational prospect, especially when employment relationships are long-term and careers are well patterned. But the gap is widening between the vocational commitment and the way it transforms into a career: self-employment, freelancing and contingent work bring in discontinuity, repeated alternation between work, compensated and non-compensated unemployment, searching and networking activities, and cycling between multiple jobs inside or outside the arts.[6]

As Menger's text implies, the temporal mentality of artistic labor (contingent, intermittent, brief) has long resembled what is now called precarity. What happens, however, when artists — who, being popularly imagined as models of precarity *avant la letter* as they do not earn steady wages in any conventional sense and have neither a secure employer nor a consistent, stable workplace — redefine art as work out of necessity, motored by a new urgency to "provide a living for your family," to cite Kinmont?

When I first conceived this chapter, I wanted to provisionally define occupational realism as it functions both as a genre or style of performance as well as an attitude towards work that sheds light on the specific class conditions of artistic production and identity. Within economics, to think occupationally means to think variously about professional status or employment; feminism further understands non-remunerative labors such as housework or child care, traditionally performed by women, as occupations. As I have been writing, and as the Occupy movement has grown around the world, I have been further impelled to rethink how "occupation" in terms of a spatial political strategy might connect to "occupational" practices that specifically interrogate labor and value. If occupational realism stems at least partially from jobs or work undertaken by artists because they "have to" (though the issue of compulsion, need, and choice is unevenly applicable), this form of practice also raises questions about the potential strategic or operational value of precarity: its capacity to redefine social relations, aesthetic and affective production, and class structures.

In addition, the language used to describe the current conditions of precarity draws heavily upon the rhetoric of performance, as performance skates the line between live art and art that is lived. According to theorist Paolo Virno,

post-Fordist capitalism, with its emphasis on flexibility, has led to an expansion of "living labor," such that not only all of our working hours, but our very desires and thoughts have been absorbed into new regimes of work.[7] But Virno sees a space of political possibility within what he calls "virtuosity," which "happens to the artist or performer who, after performing, does not leave a work of art behind."[8] Within his formulation, artistic performance (which in some Marxist understandings is posited as the paradigmatic outside, alternative, or other to deadening alienated wage labor) as a form of activity that generates surplus value without an end product, has become not a specialized case unique to performers, dancers, musicians, and the like, but has turned into the general condition of "servile" waged work. Virno writes: "The affinity between a pianist and a waiter, which Marx had foreseen, finds an unexpected confirmation in the epoch in which all wage labor has something in common with the 'performing artist.'"[9]

Virno sees virtuosity as a way to move beyond narrow considerations of political action, artistic production, and work as existing in separate spheres. For Virno, the virtuoso's activity "finds its own fulfillment" and must include an audience or "witnesses"; he stipulates that it contain some sort of public or social component.[10] Virno relies heavily upon the language of theatre; he discusses the performance, the script, the score, and the audience as he charts an opening out from work to the realms of cultural or creative activity, and finally into the sphere of the political.[11] But what about artists who move in the other direction and mine the procedures of labor in the service of their performances? How does occupational realism thematize and make legible the conditions that Virno describes, as well as indicate what Virno overlooks?

Historically speaking, a claim such as Kinmont's that his business is his art is hardly exceptional. In one sense, such an assertion is a conceptual art strategy that began in the early twentieth century with Marcel Duchamp, in which something (either an object or an idea or a gesture) is appropriated, put into quotes, framed, nominated, or bracketed "as art." In the wake of this logic, art's very contours loosened and blurred to accommodate two of its ostensible opposites: "life" and "work." There is, however, a key distinction between post-Duchampian strategies of nomination and artists who begin to understand that if their activities already resemble art, they might as well name them as such. Here, they do not "decide" to feel or think of their life or work as art, but just the opposite: they start feeling and thinking it before they know it, because of the effects that Virno describes.

Which may be why occupational realists insist on *doing the work themselves*, standing bodily in the space of labor. Hence they are also distinct from the "delegated performance" of artists like Oscar Bony whose piece *Familia Obrera*, (Working Class Family) (1968), involved paying a blue-collar worker, machinist Luis Ricardo Rodríguez, along with his wife and their ten-year-old

son, twice Rodríguez's normal hourly wage to sit on a pedestal during an art exhibition at the Instituto Di Tella in Buenos Aires.[12] Occupational realism is also different from the work of Santiago Sierra, whose performances involve hiring workers to carry out menial tasks, sometimes within the space of the art institution.

By contrast, artist Bonnie Sherk flipped hamburger patties during the graveyard shift on weekend stints under the title *Short Order Cook* (1974) at a San Francisco, California, diner called Andy's Donuts as part of her extended exploration of feminism, gendered labor, and what she referred to as "cultural costumes."[13] More recently, in 2000 Bulgarian-born Daniel Bozhkov undertook a performance in which he worked at a Maine Walmart as a "people greeter." This piece, entitled *Training in Assertive Hospitality*, involved him helping customers navigate the store; between shifts, he also painted a fresco in the Layaway Department. Occupational realists like Kinmont, Sherk, or Bozhkov do art as they work, within the normal contexts and spaces of work, and they work as they do art; this precise overlap, simultaneity, and multiplicity is crucial.[14]

But if most occupational realists are uninterested in putting their labor within the context of traditional museum or gallery display, they are equally uninterested in what could be called theatricality, if we use the basic definition of theatricality to mean "of or for the stage." Other meanings of theatricality — that which is marked by pretense, extravagant exhibitionism, or artificial emotion — further highlight what these artists are intentionally not doing. In fact, they often do not want their customers or colleagues to witness or acknowledge what they do as art — they want to vocationally "pass." Kinmont speculates that few of his customers are aware that his bookselling is also an art project — and if they are aware, they are prone to take him less seriously as a dealer. That is, though Virno's idea of the virtuoso demands an audience, that audience is here complicated and fractured — there is a "work" audience which need not or should not know that one of its workers has a value-added position as an artist, and then there is the "art" audience.

When the distinctions between art and work are eroded, does the capacity for art to critique the regimes of work likewise evaporate? Such an erasure might seem, rather, to serve neoliberal paradigms, in which all hours of the day are subsumed under the rubric of productivity. As Virno notes, the distinction between being at work and being off work (at home in domestic space or elsewhere in leisure time), has shifted into the more arbitrary differences between "remunerated life and non-remunerated life."[15] (As any freelancer knows, if you are never officially on the clock, then you never feel totally off the clock, either.) What does it mean therefore, to be at work but not occupied — that is, not fully devoting one's attentions to the task at hand? Is this partial focus assumed to be the condition of most contemporary work? How might art also speak to this space of mental elsewhereness? What position do you fill?

What space do you regularly occupy? The artists described here undermine the singular grammar demanded by these questions, as they perform roles as both artists and as wage earners. And then there is the Occupy movement.

"THIS IS MY OCCUPATION," reads a sign held aloft at an Occupy Wall Street demonstration in fall 2011 — bringing together in one terse phrase multiple definitions of employment, work, claiming territory, political strategy, and affective absorption. Indeed, if we are witnessing a wholescale economic shift whose only known contour is its very unmappability, its instability and uncertainty, in which workers of all kinds, diverse in their class status and in their various degrees of cultural capital, survive on the barest of margins, with no sense of security or futurity, then it could be that artists engaged in occupational realism prefigured the collapsing categories of work, performance, and art in precarious times.

The Occupy movement has spawned several artists' groups interested in foregrounding their own underpaid and undervalued labor as art workers, including an Arts and Labor contingent of Occupy Wall Street and an artists' bloc at Occupy San Francisco. Many in these groups are reclaiming the phrase "art worker" — a term that has been deployed at various moments in the history of the avant-garde, beginning with Russian constructivism, the 1930s Artists' Union that emerged when artists were employed through the US Works Progress Administration, and the Art Workers' Coalition (AWC), founded in 1969 in New York City. Those affiliated with the AWC called themselves "art workers," a term I used for the title of my 2009 book *Art Workers: Radical Practice in the Vietnam War Era* as a historical nod to these artists' own self-descriptors.[16] By no means did I take it as an untroubled term. It had uneven currency within its own moment, as my book elaborates, and was fraught with ambivalence, failure, and contradiction.

So I am curious, if not vaguely mystified, by how the category of the "art worker" is being resurrected. Does its most recent resurfacing mean that artists are interested in reclaiming the phrase with all of its blind spots and fault lines? What the Occupy movement's canny focus on the "99%" has offered us is a way of finding alliances without recourse to categories such as "the working class." The Occupy movement has made clear that "workers" are no longer a coherent category, and hence to organize around any single notion of employment, given its instabilities and multiplicities, makes little sense. A slogan that declares "artists are the 99%" speaks to the economic conditions of most artists, who often piece together part-time work to pay the rent, teach in adjunct positions, have mountains of student debt from their art degree, and lack health insurance.

But we need to think hard about what the phrase "art worker" means, its inconsistencies and its elisions. Is the reemergence of the term "art worker" a recognition of the pervasive blurring of art into labor, or is it an overly sim-

plistic conflation of artist and worker, yoking those two together unproblem-atically? If we can admit there is no such thing as one kind of "worker," then we must account for the fact that "artists" are likewise not a coherent cat-egory. We must keep in our focus the global art industry that maintains its connections to and is integrally part of the "1"%. We need to parse distinctions that threaten to collapse: not all art is work, not all work is art, and the class distinctions embedded within these terms still matter. Cultural production is a specialized, or as Hans Abbing calls it, "exceptional" form of work, one that has ties to markets, alternative or gift economies, and affective labor.[17] We should not erase distinctions or lose a sense of nuance in order to call for solidarity.

The Art Workers' Coalition, in its lifespan from 1969 to 1971, did accomplish many things, including an incisive institutional critique that helped illumi-nate connections between artistic industries, the military, and corporations. It agitated for more oversight in the art world in a time, then as now, with vast inequalities and a star system that rewards some and not others. But the AWC should function less as a triumphant moment than as a cautionary tale: it fell apart in part because it did not offer a sustainable analysis of the co-articu-lation of race, class, and gender. The art workers circa 1970 were never fully able to recognize this key fact: artists often have, and use, many class-based privileges that many other workers do not have, not the least of which is access to cultural capital.

How have these precarious times changed how we conceive of both art and work? If we take our cue from Virno, we might speculate that our notion of performance has undergone vast transformations that bleed from the cultur-al to the economic. Yet the contingencies upon which the idea of "artist" or "performer" rest have always in part been based on class privilege, an aspect that is underexplored in Virno. I might go so far as to say that "artists" are not "workers," which is precisely what makes occupational realism legible as a form of practice – there is a gap between these non-identical categories wide enough that their bridging feels surprising. If art were already work, or work were already art, these projects that redefine art as work and vice versa would simply fail to register as inversions, as conceptual frames, or as critiques. For many people, working and struggling to survive financially makes creating art less possible; at the same time, work contains within it the possibilities to envision new sorts of relations.

As Kathi Weeks puts it, "Work is not only a site of exploitation, domina-tion, and antagonism, but also where we might find the power to create al-ternatives on the basis of subordinated knowledges, resistant subjectivities, and emergent models of organization."[18] Potentially, the freshly minted art workers of the Occupy movement will not fixate on getting a bigger piece of the art-market pie, and instead will continue to instigate a robust, subtle, and

complex analysis of economic conditions attuned to larger struggles against inequality. This is a moment to talk openly about privilege, debt, economic justice, and art as a space of imaginative possibility that has the potential to transform how we think about work, and performance.

Notes

1. This is a radically condensed version of an essay published in *TDR: The Drama Review*; I thank Rebecca Schneider for encouraging me to contribute and for her sensitive edits. Shannon Jackson also provided helpful commentary, as did Mel Y. Chen, Matthew Jesse Jackson, Luis Jacob, and Jim Voorheis. Audiences at Extra City in Antwerp and Leuphana University Lüneburg pushed me to refine my arguments. Finally, thanks to Gregory Sholette and Oliver Ressler for inviting me to excerpt this text.

2. Joseph Beuys, *Energy Plan for the Western Man – Joseph Beuys in America*, ed. Carin Kuoni, *New York: Four Walls Eight Windows*, 1993, p. 19.

3. For more on risk as constitutive of the "new modernity," see Ulrich Beck, *Risk Society: Towards a New Modernity*, trans. Mark Ritter, Thousand Oaks, CA: Sage Publications, 1992.

4. Gerald Raunig, Gene Ray, and Ulf Wuggenig, eds., *Critique of Creativity: Precarity, Subjectivity, and Resistance in the "Creative Industries,"* London: Mayfly Books, 2011; Julieta Aranda, Brian Kuan Wood, and Anton Vidokle, eds., *Are You Working Too Much?: Post-Fordism, Precarity, and the Labor of Art*, Berlin: Sternberg Press, 2011.

As this cluster of activity suggests, 2011 was an especially fertile year for conversations about precarity, the recession, and artistic production. See also "Precarity: The People's Tribunal," convened at London's Institute of Contemporary Arts in March 2011, and Hal Foster, "Crossing Over: The Precarious Practice of Thomas Hirschhorn," *Berlin Journal,* no. 20, 2011, pp. 28–30.

5. Pascal Gielen, *The Murmuring of the Artistic Multitude: Global Art, Memory and Post-Fordism,* Amsterdam: Valiz, 2012.

6. Pierre-Michel Menger, "Artistic Labor Markets: Contingent Work, Excess Supply and Occupational Risk Management," in *Handbook of the Economics of Art and Culture,* vol. 1, ed. Victor A. Ginsburg and

David Throsby, Boston, MA: Elsevier, 2006, p. 4.

7., Paolo Virno, *A Grammar of the Multitude,* trans. Isabella Bertoletti, James Cascaito, and Andrea Casson, New York: Semiotext[e], 2004, p. 53.

8. See Pascal Gielen and Sonja Lavaert, "The Dismeasure of Art: An Interview with Paolo Virno," *Open,* no. 17, 2009, http://classic.skor.nl/article-4178-nl.html?lang=en.

9. Virno, *A Grammar*, p. 68.

10. Ibid., p. 52.

11. Ibid., p. 56.

12. Claire Bishop, "Delegated Performance: Outsourcing Authenticity," in *Artificial Hells: Participatory Art and the Politics of Spectatorship,* London and New York: Verso, 2012, pp. 219–39.

13. Will Bradley, "Let it Grow," *frieze,* no. 94, October 2005, p. 189.

14. Other artists with projects in this vein include Linda Montano, Mierle Laderman Ukeles, and Bohyun Yoon (all of whom are discussed in the original version of this chapter). In that longer text, I also consider the sociological use of the term "occupational realism," which considers how "realistic" it is for low-income job-seekers to aspire to certain occupations given their class staus, their level of education, their race, and/or their gender.

15. Virno, *A Grammar*, p. 103.

16. Julia Bryan-Wilson, *Art Workers: Radical Practice in the Vietnam War Era,* Berkeley: University of California Press, 2009.

17. Hans Abbing, *Why are Artists Poor?: The Exceptional Economy of the Arts,* Amsterdam: Amsterdam University Press, 2002.

18. Kathi Weeks, *The Problem with Work: Feminism, Marxism, Antiwork Politics, and Postwar Imaginaries,* Durham, NC: Duke University Press, 2011, p. 29.

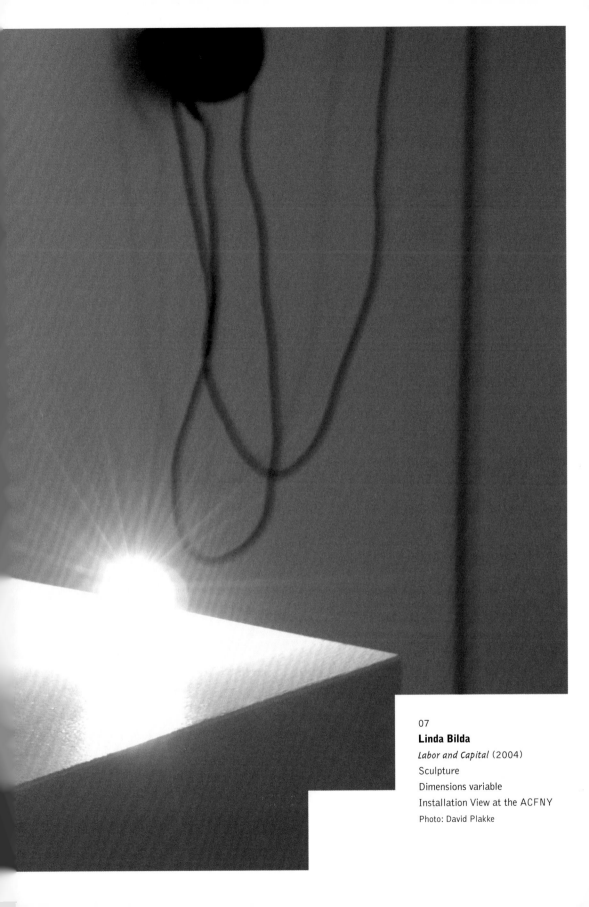

07
Linda Bilda
Labor and Capital (2004)
Sculpture
Dimensions variable
Installation View at the ACFNY
Photo: David Plakke

5a

Comments on Art from the Exhibition It's the Political Economy, Stupid

Angela Dimitrakaki & Kirsten Lloyd

Linda Bilda
flo6x8
Jan Peter Hammer
Sherry Millner and Ernie Larsen

Unapologetically representational, **Linda Bilda**'s art narrativizes capitalist relations of production. "It's really that simple," is the impression given by the dance of *Labor and Capital* – the dance, that is, of a see-through young woman and a luminous, yellow shark. Despite his imposing size, capital/the shark is clearly out of his depth or rather out of the water altogether. After all, "he" is called to perform in the world of Labor, the one "she" shares with the spectators, and where creatures are most successful when they have feet rather than fishtails. Women's feet, specifically. The "feminization of labor," a concept widely used in globalization theory from the late 1980s onwards, entails a double-edged meaning, referring to the number of women entering waged labor as well as to the denigration, or even proper *devaluation*, of labor in contemporary (global) capitalism. This is one occasion where the "feminization of labor" is explicitly posited as the Significant Other to the dehumanization of capital, hereby understood as a form of aggressive monstrosity. And yet there is something ridiculous in a predatory shark that tries to dance.

Overall, Bilda makes confident use of the absurd in her depictions of social relations that are trapped within the principles of capitalist accumulation. *The Future and End of the Golden World*, a story about competition as the cornerstone of capitalist accumulation, takes the form of a comic strip that has gone rhizomatic: competition extending in all possible directions, claiming (and closing) all gaps. The storyline is initiated by a dead male billionaire who took steps to ensure that he could contribute to strengthening the capitalist logic of pitching one human being against another from beyond the grave. Decreeing that only one of his heirs would inherit, based on their ability to accumulate the most profit within a year, his legacy would effectively be a practical application of Marx's insightful way of connecting the seemingly antithetical principles of competition and monopoly. Indeed, feudal monopoly was something quite different to modern (capitalist) monopoly, as Marx observed a century and a half ago in *The Poverty of Philosophy*. Yet, given that Bilda's work was produced in 2011, one wonders to what extent the global crisis that began unfolding in 2008 with the collapse of the Lehmann Brothers has been modifying the script. In 2006, David Harvey had already posed the question: "Why, in a neoliberal world where competitive markets are supposedly dominant, would monopoly of any sort be tolerated, let alone be seen as desirable?" *The Future and End of the Golden World* offers a funny yet not inconceivable answer: it is a contradiction handed down to capitalist generations from the world of the dead, always weighing on the minds, and

08
Linda Bilda
Detail from
The Future and End of the Golden World (2011)
Wall mural
Dimensions variable

economies, of the living. It is indeed a joke at the living's expense, a way of draining away, regulating, streamlining, making predictable their *life*.

Traditionally, it has been feminist rather than Marxist theory that has looked at the production of the body through the birth canals of capital. What the previous sentence implies is also a disjuncture between feminism and Marxism, an antagonism running through the histories of the radical 1960s and 1970s – from the annals of the Italian Autonomia, concerning practices of networked yet liberated living, to the emergence of Anglophone New Art History, concerning practices of thinking that would forever transform the ways art becomes integrated into the social process. Years later the division would be summed up and reaffirmed by *Documenta II* reviewers who welcomed – at long last – a serious show that had given up fluids, sexuality, and the body to focus on truly serious matters such as global poverty. Published in 2002, these reviews dovetailed with a new division emerging in left

theory: the partition between material and immaterial labor, setting in place the dualism that was to define the coming decade.

By 2012 the division still stands, enlivened by debates where the body has been at best acknowledged as a tool, a technology of the flesh, harnessed into the forces of production required by a capital that has increasingly signified as pure abstraction, an *alpha immateriality*. At worse, the body is typically now associated with an outmoded 1980s discourse on orifices and a cult of abjection as well as a more or less ludicrous nihilism promoting a politics of the corpse (Hal Foster) and a naïve infantilism that would, clearly, never amount to anything but a breeze against the insulated sleek, seamless curvatures of global capital (Susan Buck-Morss). But also by 2012, there have been four years of particularly intense protests against the reign of capital where both the body and technology have been re-signified: technology, invested in social media, has become an alarm bell, capable of sending masses of people to the

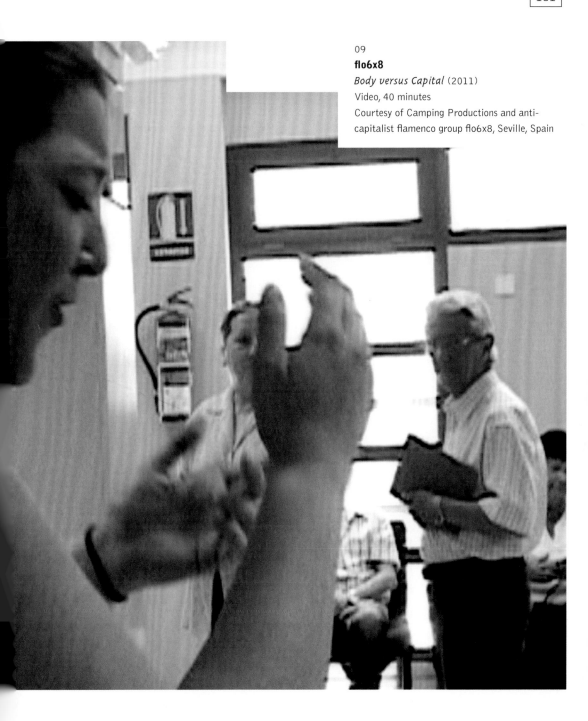

09
flo6x8
Body versus Capital (2011)
Video, 40 minutes
Courtesy of Camping Productions and anti-capitalist flamenco group flo6x8, Seville, Spain

streets for embodied participation in struggles. Spain, the homeland of **flo6x8**, has been a stronghold of this recent revalorization of the body as a *sensual* battlefront. In their video piece *Body versus Capital* (2011), CCTV and news footage is featured in audio-visual documents of the flash-mob-style action (unthinkable without the possibilities of organizing ad hoc assemblies opened up by social media). These may be grappling with the transformation of the sensual as sensational, but this is a fairly easy and familiar equation: action excluding participation generates spectacle. The salutary radicalism of *Body versus Capital* is in the act of dancing, of taking pleasure in the body's exuberant capacities and *demanding* the right of access to such pleasure for all. Executing their dance in banks and the like, flo6x8 achieve a great deal: first, they disrupt production, they prevent the bank workers from working. Second, they make apparent the revolutionary possibility of opposing the wonderful materiality of the body

(its sheer power of presence, the inevitability of its needs) to the imaginary sums of finance. Finance does not *really* exist: much like Spain's debt, for which nevertheless millions of bodies are condemned to misery. Third, they gender the process of illumination, and of the body's radicalization.

The flamenco dancers of flo6x8 are overwhelmingly female. And, as Terry Eagleton once commented in his discussion of ideology, there are good reasons why a student movement is headed by students and feminist struggles are headed by women. Second-wave feminists made indisputably clear that women have long been (negatively) identified with the corporeal dimension of existence. In this day and age of unmitigated abstractions, to engage the body as the site of pleasure-turned-resistance truly does bring forth the possibility

of a new vanguard: one which reworks the art/life relationship to give form – in this case, dance in banks – a leading role. The first difference is that now, after many years of feminist struggle, *women, alongside anyone who feels like a woman,* can deploy their bodies to front a rising wave of resistance on behalf of all genders and all humanity.

A formidably layered work on capital as a set of internalized values, **Jan Peter Hammer**'s *The Anarchist Banker* (2010) can be approached from at least two angles. First, with the question: why fictionalize? What is the good of unreal narratives generated for the purpose of explicating real relations? The video takes its title and central concept from a poet's (Pessoa of Portugal) short story in which a relationship between a banker and his secretary is similarly performed through a conversation. Why not merely record some analytical commentary tackling the same subjects? Pessoa felt the need to write his two-hander in 1922, between two devastating world wars and before the

capitalists' ingenious move to liberate capital from the world of objects via the Bretton Woods agreement in 1944. Almost a century later, Jan Peter Hammer has opted to rework Pessoa's material, updating it to reflect the particularities of more contemporary crises. The dialogue between the banker claiming his emancipated subjectivity in opportunities of *exceptional* exploitation afforded by the fully abstracted markets now finds an interlocutor in the face of a TV presenter, the shaman of media societies responsible for eliding the difference between fact and fiction on a daily basis.

The arguments advanced by Hammer's banker, Arthur Ashenking, spur the second angle: did the birth of the individual lead to capitalism or vice versa? What is the connection between the radical self-assertion of an "I," as the cornerstone of Western civilization, and the operations of the exceptional individual who either rejects or sustains this civilization? Over the course of a very long century, we have lived in a capitalism

Jan Peter Hammer
The Anarchist Banker (2010)
Video, 30 minutes
Courtesy of Supportico Lopez Gallery,
Berlin, Germany

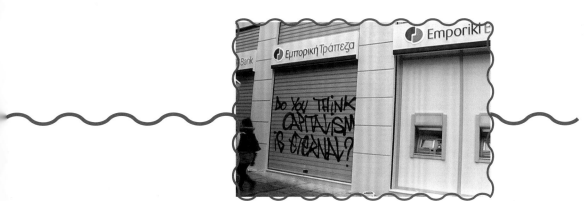

that mass-produces individuality. The ideology of difference has engendered the out-of-the-box great thinker of the neoliberal era, from the visionary CEO or business consultant to the drug cartel baron. It has also given us the bohemian exceptionalism of the modern artist. The "radical chic" ethos now proliferating across management discourse has been linked back to the co-option of 1960s creative drive and political subversion, although Ashenking's (and Pessoa's character before him) polemics are anchored within even deeper anti-establishment roots. *The Anarchist Banker* connects such sociological analyses into the nature of contemporary work with the (by the 2010s) highly popular mission to unpick the psychological make-up of the financier-cum-tycoon. For, we are repeatedly told, it is at this greedy – even psychopathic – figure's door that the blame can be laid. That the debate is played out on the grounds of ethics and morality rather than politics makes it all the more relevant to present circumstances: Ashenking's

claims that liberation can be realized through his "moral fight" to subjugate money can be set against the demand for an ethical brand of capitalism capable of harnessing the wit and entrepreneurial successes of such individuals while curtailing their dissent into twisted rapacity. As the concluding scenes of *Wall Street: Money Never Sleeps* assure, the exceptional individual is indeed capable of such personal growth beyond the realms of self-interest and may indeed instigate the emergence of such an ethically-based future.

And yet, whichever angle one wishes to pursue, the crux of the story told lies elsewhere: angle one and angle two connect at the realization that an aesthetic rendering either of discourse (writing down a short story) or action (burning down the local branch of a global bank) cannot match the recombinant effect of capital as discursive action. And so, art will remain art – always leaning on fiction, on the individual, on its own exceptionalism – until it learns to do a lot better what capital

does so well: *show us how we think we want to live.*

How do you join a struggle? How do you make it collective and common? When are others' politics also your own, and is there an aesthetic language for sharing, rather than merely telling, the story? What does it mean to make a record out of history in the making? Is the early twenty-first century a moment of rupture where humanity can find its lost core of decency in small-scale insurrections against a totalizing political economy? Many other questions – and emotions – enter the plane of consciousness as one watches **Sherry Millner and Ernie Larsen**'s stunning portrayal of the anarchists' response to the new misery of everyday life in besieged Greece.

The setting is Greece's second largest city, Thessaloniki, also known as the country's capital of the north, or else Macedonia. Up to the post-1989 reshuffling of European history, many Greeks would have been ignorant of the fact that Macedonia is a transnational territory exceeding the northern Greek border. The Thessaloniki anarchists operate therefore within an overcharged territorial paradigm, a messy reorganization of Balkan geopolitics and the ludicrous aspiration of "Greek" capital to claim regional leadership. This is the undercurrent of the video essay, rendered audible when the anarchists chant in the demo: "Greece, Turkey, Macedonia, the real enemy is in the banks and state ministries!" They voice the unthinkable, they advocate the utopian: that overexploited labor divided into convincing old and new nationalisms might actually rid itself of its false consciousness.

Oscillating between meditative commentary and active engagement, Millner and Larsen's video essay bears a title that registers as a call to arms

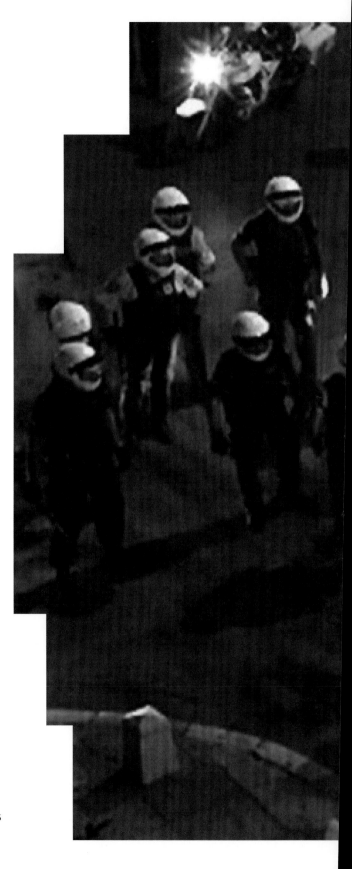

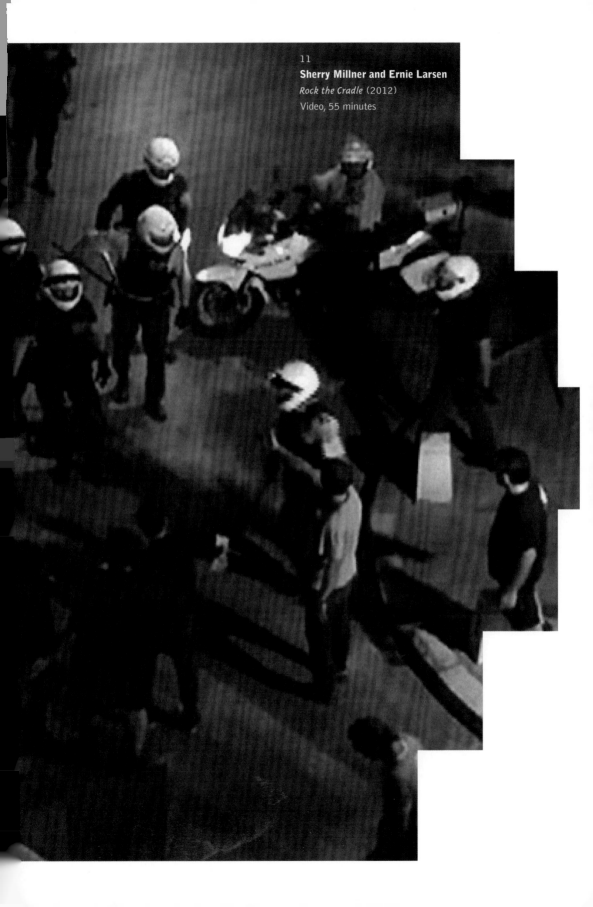

11
Sherry Millner and Ernie Larsen
Rock the Cradle (2012)
Video, 55 minutes

against the demotion of what we might call "deep democracy": *Rock the Cradle* – meaning, make something happen in the land where once things did. Yet in this video essay, which generates a widescreen image of history out of a narrow real-moment of confrontational street politics, Greece in the throes of its Death-by-IMF acquires a metaphoric capacity. The country's proud-turned-melancholic identity as the birthplace of democracy is at least implicitly extended to a contemporary global identity where the breach of the pact between democracy and capital can be sorely observed. *Capital no longer needs democracy*: this is the ineffable condition in Millner and Larsen's record of a slice-of-struggle. The French Revolution, which legitimated the bourgeois

notion of "one" entering the market as equal, and which in turn legitimated a republic of "free" sellers and buyers, is undergoing a major defeat. This defeat, together with its exorcised counter-moment of the massacred French communards of the nineteenth century, provide the starting point for *Rock the Cradle* as it picks up the thread for the twenty-first century.

The aftermath of these old defeats is one of unmitigated brutality. Millner and Larsen have stitched together an array of violent dispositions: the violence done by cars speeding indifferently in front of broken sculpture, the violence done to those rejecting authority by those representing it (or better, *inflicting* it), the violence of hate-language passing between police and protesters, the violence of teargas in

a demo clash, the violence of capital against what passes for normal life, the violence of acid thrown in the face of a female, migrant union leader. This last violence, performed on December 23, 2009, against Konstantina Kouneva, underwrites all other forms of violence negotiated in the video essay. The meaning of this violence becomes more pronounced when Millner and Larsen are seen to be spared a police attack during a demo by being identified as "American tourists": naïve, apolitical, harmless and protected by the biggest US embassy in the region. And yet, in the narrative of *Rock the Cradle*, Greece's "American tourists" stand for the old divisions of power. The privileged subjects of a dying world, "American tourists" is now the lie whispered anxiously by a twenty-first-century marching Greek anarchist to a charging Greek policeman – a lie with which the Greek anarchist ensures the safety of his two American comrades. Surely, the global cradle is being rocked.

11

OCCUPY WALL STREET'S ANARCHIST ROOTS[1]

6

David Graeber

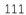

Almost every time I'm interviewed by a mainstream journalist about Occupy Wall Street I get some variation of the same lecture:

How are you going to get anywhere if you refuse to create a leadership structure or make a practical list of demands? And what's with all this anarchist nonsense – the consensus, the sparkly fingers? Don't you realize all this radical language is going to alienate people? You're never going to be able to reach regular, mainstream Americans with this sort of thing!

If one were compiling a scrapbook of worst advice ever given, this sort of thing might well merit an honorable place. After all, since the financial crash of 2007, there have been dozens of attempts to kick-off a national movement against the depredations of the United States' financial elites taking the approach such journalists recommended. All failed. It was only on August 2, 2011, when a small group of anarchists and other anti-authoritarians showed up at a meeting called by one such group and effectively wooed everyone away from the planned march and rally to create a genuine democratic assembly, on basically anarchist principles, that the stage was set for a movement that Americans from Portland to Tuscaloosa were willing to embrace.

I should be clear here what I mean by "anarchist principles." The easiest way to explain anarchism is to say that it is a political movement that aims to bring about a genuinely free society — that is, one where humans only enter those kinds of relations with one another that would not have to be enforced by the constant threat of violence. History has shown that vast inequalities of wealth, institutions like slavery, debt peonage, or wage labor can only exist if backed up by armies, prisons, and police. Anarchists wish to see human relations that would not have to be backed up by armies, prisons, and police. Anarchism envisions a society based on equality and solidarity, which could exist solely on the free consent of participants.

Anarchism versus Marxism

Traditional Marxism, of course, aspired to the same ultimate goal but there was a key difference. Most Marxists insisted that it was necessary first to seize state power, and all the mechanisms of bureaucratic violence that come with it, and use them to transform society — to the point where, they argued, such mechanisms would, ultimately, become redundant and fade away. Even back in the nineteenth century, anarchists argued that this was a pipe dream. One cannot, they argued, create peace by training for war, equality by creating top-down chains of command, or, for that matter, human happiness by becoming grim joyless revolutionaries who sacrifice all personal self-realization or self-fulfillment to the cause.

It's not just that the ends do not justify the means (though they don't),

you will never achieve the ends at all unless the means are themselves a model for the world you wish to create. Hence the famous anarchist call to begin "building the new society in the shell of the old" with egalitarian experiments ranging from free schools to radical labor unions to rural communes.

Anarchism was also a revolutionary ideology, and its emphasis on individual conscience and individual initiative meant that during the first heyday of revolutionary anarchism between roughly 1875 and 1914, many took the fight directly to heads of state and capitalists, with bombings and assassinations. Hence the popular image of the anarchist bomb-thrower. It's worthy of note that anarchists were perhaps the first political movement to realize that terrorism, even if not directed at innocents, doesn't work. For nearly a century now, in fact, anarchism has been one of the very few political philosophies whose exponents never blow anyone up (indeed, the twentieth-century political leader who drew most from the anarchist tradition was Mohandas K. Gandhi).

Yet for the period of roughly 1914–89, a period during which the world was continually either fighting or preparing for world wars, anarchism went into something of an eclipse for precisely that reason: to seem "realistic," in such violent times, a political movement had to be capable of organizing armies, navies, and ballistic missile systems, and that was one thing at which Marxists could often excel. But everyone recognized that anarchists — rather to their credit — would never be able to pull it off. It was only after 1989, when the age of great-war mobilizations seemed to have ended, that a global revolutionary movement based on anarchist principles — the global justice movement — promptly reappeared.

How, then, did Occupy Wall Street embody anarchist principles? It might be helpful to go over this point by point:

1. The Refusal to Recognize the Legitimacy of Existing Political Institutions

One reason for the much-discussed refusal to issue demands is because issuing demands means recognizing the legitimacy — or at least, the power — of those of whom the demands are made. Anarchists often note that this is the difference between protest and direct action: protest, however militant, is an appeal to the authorities to behave differently; direct action, whether it's a matter of a community building a well or making salt in defiance of the law (Gandhi's example again), trying to shut down a meeting or occupy a factory, is a matter of acting as if the existing structure of power does not even exist. Direct action is, ultimately, the defiant insistence on acting as if one is already free.

2. The Refusal to Accept the Legitimacy of the Existing Legal Order

The second principle, obviously, follows from the first. From the very beginning, when we first started holding planning meetings in Tompkins Square Park in New York, organizers knowingly ignored local ordinances that insisted that any gathering of more than twelve people in a public park is illegal without police permission — simply on the grounds that such laws should not exist. On the same grounds, of course, we chose to occupy a park, inspired by examples from the Middle East and Southern Europe, on the grounds that, as the public, we should not need permission to occupy public space. This might have been a very minor form of civil disobedience but it was crucial that we began with a commitment to answer only to a moral order, not a legal one.

3. The Refusal to Create an Internal Hierarchy, but Instead to Create a Form of Consensus-based Direct Democracy

From the very beginning, too, organizers made the audacious decision to operate not only by direct democracy, without leaders, but by consensus. The first decision ensured that there would be no formal leadership structure that could be co-opted or coerced; the second, that no majority could bend a minority to its will, but that all crucial decisions had to be made by general consent. American anarchists have long considered consensus process (a tradition that has emerged from a confluence of feminism, anarchism, and spiritual traditions like the Quakers) crucial for the reason that it is the only form of decision-making that could operate without coercive enforcement — since if a majority does not have the means to compel a minority to obey its dictates, all decisions will, of necessity, have to be made by general consent.

4. The Embrace of Prefigurative Politics

As a result, Zuccotti Park (the privately managed plaza in lower Manhattan where the Occupy Wall Street protest camp was initiated on September 17, 2011), and all subsequent encampments, became spaces of experiment with creating the instittions of a new society — not only democrat-ic general assemblies but kitchens, libraries, clinics, media centers, and a host of other institutions, all operating on anarchist principles of mutual aid and self-organization — a genuine attempt to create the institutions of a new society in the shell of the old.

Why did it work? Why did it catch on? One reason is, clearly, because most Americans are far more willing to embrace radical ideas than anyone in the established media is willing to admit. The basic message — that the American political order is absolutely and irredeemably corrupt, that both parties have been bought and sold by the wealthiest 1 percent of the population, and that if we are to live in any sort of genuinely democratic society, we're going to have to start from scratch — clearly struck a profound chord in the American psyche.

Perhaps this is not surprising: we are facing conditions that rival those of the 1930s, the main difference being that the media seems stubbornly unwilling to acknowledge it. It raises intriguing questions about the role of the media itself in American society. Radical critics usually assume the "corporate media," as they call it, mainly exists to convince the public that existing institutions are healthy, legitimate and just. It is becoming increasingly apparent that they do not really see this is possible; rather, their role is simply to convince members of an increasingly angry public that no one else has come to the same conclusions they have. The result is an ideology that no one really believes, but most people at least suspect that everybody else does.

Nowhere is this disjunction between what ordinary Americans really think, and what the media and political establishment tells them they think, more clear than when we talk about democracy.

Democracy in America?

According to the official version, of course, "democracy" is a system created by the Founding Fathers, based on checks and balances between President, Congress, and judiciary. In fact, nowhere in the Declaration of Independence or the Constitution does it say anything about the US being a "democracy." The authors of those documents, almost to a man, defined "democracy" as a matter of collective self-governance by popular assemblies, and as such they were dead-set against it.

Democracy meant the madness of crowds: bloody, tumultuous, and untenable. "There was never a democracy that didn't commit suicide," wrote Adams; Hamilton justified the system of checks and balances by insisting that it was necessary to create a permanent body of the "rich and well-born" to check the "imprudence" of democracy, or even that limited form that would be allowed in the lower House of Representatives.

The result was a republic — modeled not on Athens, but on Rome. It only came to be redefined as a "democracy" in the early nineteenth century because ordinary Americans had very different views, and persistently

tended to vote — those who were allowed to vote — for candidates who called themselves "democrats." But what did — and what do — ordinary Americans mean by the word? Did they really just mean a system where they get to weigh in on which politicians will run the government? It seems implausible. After all, most Americans loathe politicians, and tend to be skeptical about the very idea of government. If they universally hold out "democracy" as their political ideal, it can only be because they still see it, however vaguely, as self-governance — as what the Founding Fathers tended to denounce as either "democracy" or, as they sometimes also put it, "anarchy."

If nothing else, this would help explain the enthusiasm with which they have embraced a movement based on directly democratic principles, despite the uniformly contemptuous dismissal of the United States' media and political class.

In fact, this is not the first time a movement based on fundamentally anarchist principles — direct action, direct democracy, a rejection of existing political institutions and attempt to create alternative ones — has cropped up in the US. The civil rights movement (at least its more radical branches), the anti-nuclear movement, and the global justice movement all took similar directions. Never, however, has one grown so startlingly quickly. But in part, this is because this time around, the organizers went straight for the central contradiction. They directly challenged the pretenses of the ruling elite that they are presiding over a democracy.

When it comes to their most basic political sensibilities, most Americans are deeply conflicted. Most combine a deep reverence for individual freedom with a near-worshipful identification with institutions like the army and police. Most combine an enthusiasm for markets with a hatred of capitalists. Most are simultaneously profoundly egalitarian, and deeply racist. Few are actual anarchists; few even know what "anarchism" means; it's not clear how many, if they did learn, would ultimately wish to discard the state and capitalism entirely. Anarchism is much more than simply grassroots democracy: it ultimately aims to eliminate all social relations, from wage labor to patriarchy that can only be maintained by the systematic threat of force.

But one thing overwhelming numbers of Americans do feel is that something is terribly wrong with their country, that its key institutions are controlled by an arrogant elite, that radical change of some kind is long since overdue. They're right. It's hard to imagine a political system so systematically corrupt — one where bribery, on every level, has not only been made legal, but soliciting and dispensing bribes has become the full-time occupation of every American politician. The outrage is appropriate. The problem is that up until September 17, 2011, the only side of the spectrum willing to propose radical solutions of any sort was the Right.

As the history of the past movements all make clear, nothing terri-

fies those running the US more than the danger of democracy breaking out. The immediate response to even a modest spark of democratically organized civil disobedience is a panicked combination of concessions and brutality. How else can one explain the recent national mobilization of thousands of riot cops, the beatings, chemical attacks, and mass arrests, of citizens engaged in precisely the kind of democratic assemblies the Bill of Rights was designed to protect, and whose only crime — if any — was the violation of local camping regulations?

Our media pundits might insist that if average Americans ever realized the anarchist role in Occupy Wall Street, they would turn away in shock and horror; but our rulers seem, rather, to labor under a lingering fear that if any significant number of Americans do find out what anarchism really is, they might well decide that rulers of any sort are unnecessary.

Note

1. This chapter first appeared in *Al Jazeera* online edition, November 30, 2011, http://www.aljazeera.com/indepth/ opinion/2011/11/2011112872835904508.html. It is reprinted here with the kind permission of the author.

BODIES IN ALLIANCE AND THE POLITICS OF THE STREET[1]

Judith Butler

In the last months there have been,
time and again, mass demonstrations
on the street, in the square, and
though these are very often
motivated by different political
purposes, something similar happens:
bodies congregate, they move and
speak together, and they lay claim
to a certain space as public space.

Now, it would be easier to say that these demonstrations or, indeed, these movements, are characterized by bodies that come together to make a claim in public space, but that formulation presumes that public space is given, that it is already public, and recognized as such. We miss something of the point of public demonstrations if we fail to see that the very public character of the space is being disputed and even fought over when these crowds gather. So though these movements have depended on the prior existence of pavement, street, and square, and have often enough gathered in squares, like Tahrir, whose political history is potent, it is equally true that the collective actions collect the space itself, gather the pavement, and animate and organize the architecture. As much as we must insist on there being material conditions for public assembly and public speech, we have also to ask how it is that assembly and speech reconfigure the materiality of public space, and produce, or reproduce, the public character of that material environment. And when crowds move outside the square, to the side street or the back alley, to the neighborhoods where streets are not yet paved, then something more happens. At such a moment, politics is no longer defined as the exclusive business of public sphere distinct from a private one, but it crosses that line again and again, bringing attention to the way that politics is already in the home, or on the street, or in the neighborhood, or indeed in those virtual spaces that are unbound by the architecture of the public square. So when we think about what it means to assemble in a crowd, a growing crowd, and what it means to move through public space in a way that contests the distinction between public and private, we see some way that bodies in their plurality lay claim to the public, find and produce the public through seizing and reconfiguring the matter of material environments; at the same time, those material environments are part of the action, and they themselves act when they become the support for action. In the same way, when trucks or tanks suddenly become platforms for speakers, then the material environment is actively reconfigured and re-functioned, to use the Brechtian term. And our ideas of action then need to be rethought. In the first instance, no one mobilizes a claim to move and assemble freely without moving and assembling together with others. In the second instance, the square and the street are not only the material supports for action, but they themselves are part of any theory of public and corporeal action that we might propose. Human action depends upon all sorts of supports — it is always supported action. But in the case of public assemblies, we see quite clearly not only that there is a struggle over what will be public space, but a struggle as well over those basic ways in which we are, as bodies, supported in the world — a struggle against disenfranchisement, effacement, and abandonment.

For politics to take place, the body must appear. I appear to others, and they appear to me, which means that some space between us allows each

to appear. We are not simply visual phenomena for each other — our voices must be registered, and so we must be heard; rather, who we are, bodily, is already a way of being "for" the other, appearing in ways that we cannot see, being a body for another in a way that I cannot be for myself, and so dispossessed, perspectivally, by our very sociality. I must appear to others in ways for which I cannot give an account, and in this way my body establishes a perspective that I cannot inhabit. This is an important point because it is not the case that the body only establishes my own perspective; it is also that which displaces that perspective, and makes that displacement into a necessity. This happens most clearly when we think about bodies that act together. No one body establishes the space of appearance, but this action, this performative exercise happens only "between" bodies, in a space that constitutes the gap between my own body and another's. In this way, my body does not act alone, when it acts politically. Indeed, the action emerged from the "between."

What bodies are doing on the street when they are demonstrating is linked fundamentally to what communication devices and technologies are doing when they "report" on what is happening in the street. These are different actions, but they both require bodily actions. The one exercise of freedom is linked to the other exercise, which means that both are ways of exercising rights, and that jointly they bring a space of appearance into being and secure its transposability. Although some may wager that the exercise of rights now takes place quite at the expense of bodies on the street, that Twitter and other virtual technologies have led to a disembodiment of the public sphere, I disagree. The media requires those bodies on the street to have an event, even as the street requires the media to exist in a global arena. But under conditions when those with cameras or internet capacities are imprisoned or tortured or deported, then the use of the technology effectively implicates the body. Not only must someone's hand tap and send, but someone's body is on the line if that tapping and sending gets traced. In other words, localization is hardly overcome through the use of a media that potentially transmits globally. And if this conjuncture of street and media constitutes a very contemporary version of the public sphere, then bodies on the line have to be thought as both there and here, now and then, transported and stationary, with very different political consequences following from those two modalities of space and time.

It matters that it is public squares that are filled to the brim, that people eat and sleep there, sing and refuse to cede that space, as we saw in Tahrir Square, and continue to see on a daily basis. It matters as well that it is public educational buildings that have been seized in Athens, London, and Berkeley. At Berkeley, buildings were seized, and trespassing fines were handed out. In some cases, students were accused of destroying private property. But these very allegations raised the question of whether the university is public or

private. The stated aim of the protest — to seize the building and to sequester themselves there — was a way to gain a platform; indeed, a way to secure the material conditions for appearing in public. Such actions generally do not take place when effective platforms are already available. The students there, but also at Goldsmiths College in the UK more recently, were seizing buildings as a way to lay claim to buildings that ought properly, now and in the future, to belong to public education. That doesn't mean that every time these buildings are seized it is justifiable, but let us be alert to what is at stake here: the symbolic meaning of seizing these buildings is that these buildings belong to the public, to public education; it is precisely the access to public education which is being undermined by fee and tuition hikes and budget cuts; we should not be surprised that the protest took the form of seizing the buildings, performatively laying claim to public education, insisting on gaining literal access to the buildings of public education precisely at a moment, historically, when that access is being shut down. In other words, no positive law justifies these actions that oppose the institutionalization of unjust or exclusionary forms of power. So can we say that these actions are nevertheless an exercise of a right and, if so, what kind?

To walk on the street without police interference is something other than assembling there en masse. And yet, when a transgendered person walks there, the right that is exercised in a bodily form does not only belong to that one person. There is a group, if not an alliance, walking there, too, whether or not they are seen. Perhaps we can call "performative" both this exercise of gender and the embodied political claim to equal treatment, to be protected from violence, and to be able to move with and within this social category in public space. To walk is to say that this is a public space in which transgendered people walk, that this is a public space where people with various forms of clothing, no matter how they are gendered or what religion they signify, are free to move without threat of violence. But this performativity applies more broadly to the conditions by which any of us emerge as bodily creatures in the world.

How, finally, do we understand this body? Is it a distinctively human body, a gendered body, and is it finally possible to distinguish between that domain of the body that is given and that which is made? If we invest in humans the power to make the body into a political signifier, then do we assume that in becoming political, the body distinguishes itself from its own animality and the sphere of animals? In other words, how do we think this idea of the exercise of freedom and rights within the space of appear-ance that takes us beyond anthropocentrism? Here again, I think the con-ception of the living body is key. After all, the life that is worth preserving, even when considered exclusively human, is connected to non-human life in essential ways; this follows from the idea of the human animal. Thus, if

we are thinking well, and our thinking commits us to the preservation of life in some form, then the life to be preserved takes a bodily form. In turn, this means that the life of the body — its hunger, its need for shelter and protection from violence — would all become major issues of politics. Even the most given or non-chosen features of our lives are not simply given; they are given *in* history and *in* language, in vectors of power that none of us chose. Equally true is that a given property of the body or a set of defining characteristics depend upon the continuing persistence of the body. Those social categories we never chose traverse this body that is given in some ways rather than in others, and gender, for instance, names that traversal as well as the trajectory of its transformations. In this sense, those most urgent and non-volitional dimensions of our lives, which include hunger and the need for shelter, medical care, and protection from violence, natural or humanly imposed, are crucial to politics. We cannot presume the enclosed and well-fed space of the Polis where all the material needs are somehow being taken care of elsewhere by beings whose gender, race, or status render them ineligible for public recognition. Rather, we have to not only bring the material urgencies of the body into the square, but make those needs central to the demands of politics.

In my view, a different social ontology would have to start from the presumption that there is a shared condition of precarity that situates our political lives. And some of us, as Ruthie Gilmore has made very clear, are disproportionately disposed to injury and early death than others, and racial difference can be tracked precisely through looking at statistics on infant mortality; this means, in brief, that precarity is unequally distributed and that lives are not considered equally grievable or equally valuable. If, as Adriana Cavarero has argued, the exposure of our bodies in public space constitutes us fundamentally, and establishes our thinking as social and embodied, vulnerable, and passionate, then our thinking gets nowhere without the presupposition of that very corporeal interdependency and entwinement. The body is constituted through perspectives it cannot inhabit; someone else sees our face in a way that none of us can. We are in this way, even as located, always elsewhere, constituted in a sociality that exceeds us. This establishes our exposure and our precarity, the ways in which we depend on political and social institutions to persist.

After all, in Cairo, it was not just that people amassed in the square: they were there; they slept there; they dispensed medicine and food, they assembled and sang, and they spoke. Can we distinguish those vocalizations from the body from those other expressions of material need and urgency? They were, after all, sleeping and eating in the public square, constructing toilets and various systems for sharing the space, and so not only refusing to be privatized — refusing to go or stay home — and not only claiming the public domain for themselves — acting in concert on conditions of equality —

but also maintaining themselves as persisting bodies with needs, desires, and requirements. Arendtian and counter-Arendtian, to be sure. Since these bodies who were organizing their most basic needs in public were also petitioning the world to register what was happening there, to make its support known, and in that way to enter into revolutionary action itself. The bodies acted in concert, but they also slept in public, and in both these modalities, they were both vulnerable and demanding, giving political and spatial organization to elementary bodily needs. In this way, they formed themselves into images to be projected to all of who watched, petitioning us to receive and respond, and so to enlist media coverage that would refuse to let the event be covered over or to slip away. Sleeping on that pavement was not only a way to lay claim to the public, to contest the legitimacy of the state, but also, quite clearly, a way to put the body on the line in its insistence, obduracy and precarity, overcoming the distinction between public and private for the time of revolution. In other words, it was only when those needs that are supposed to remain private came out into the day and night of the square, formed into image and discourse for the media, did it finally become possible to extend the space and time of the event with such tenacity to bring the regime down. After all, the cameras never stopped, bodies were there and here, they never stopped speaking, not even in sleep, and so could not be silenced, sequestered, or denied — revolution happened because everyone refused to go home, cleaving to the pavement, acting in concert.

Note

1. Judith Butler's lecture was held in Venice on 7 September 2011 within the framework of the series "The State of Things," organized by the Office for Contemporary Art Norway (OCA), it was subsequently published online in the eipcp web journal *Transversal*, http://eipcp.net/transversal/1011/. It is reprinted here in edited form with the kind permission of the author.

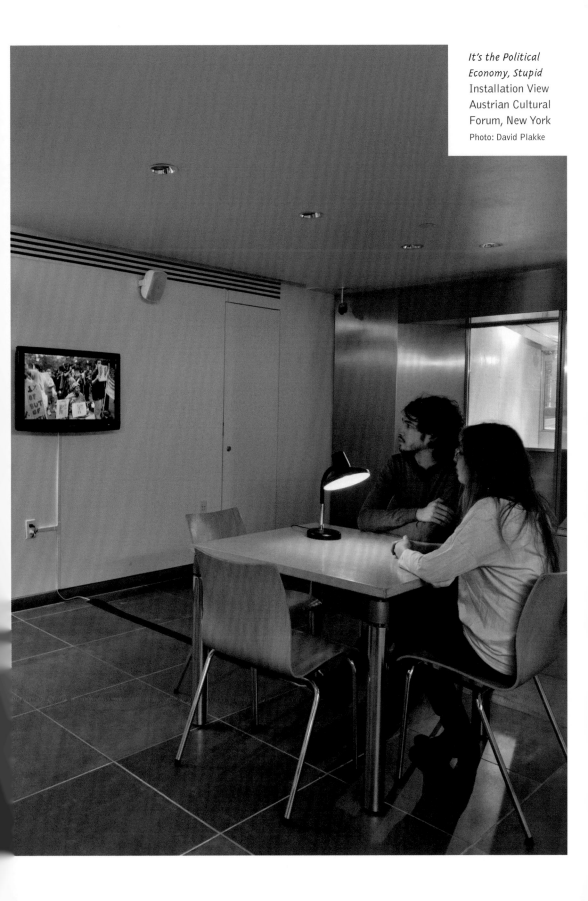

It's the Political Economy, Stupid
Installation View
Austrian Cultural
Forum, New York
Photo: David Plakke

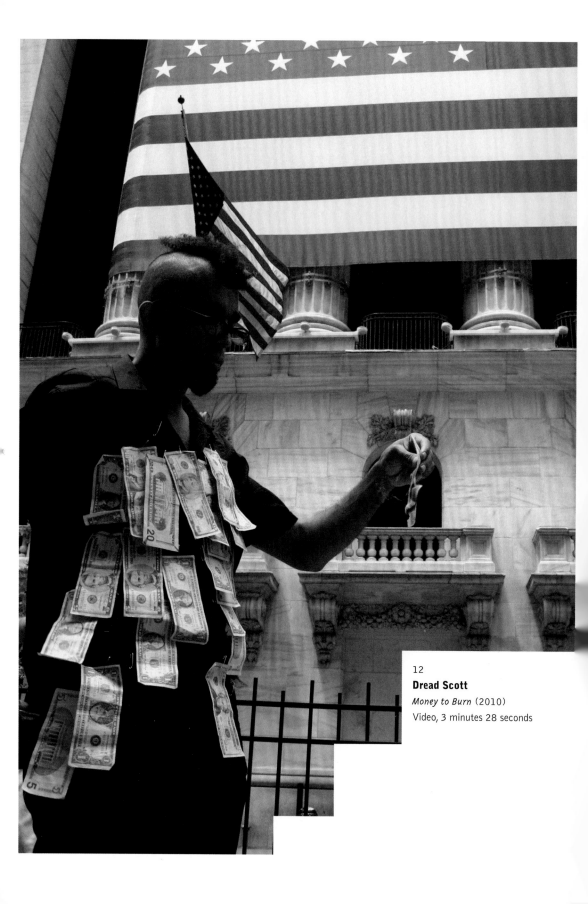

12
Dread Scott
Money to Burn (2010)
Video, 3 minutes 28 seconds

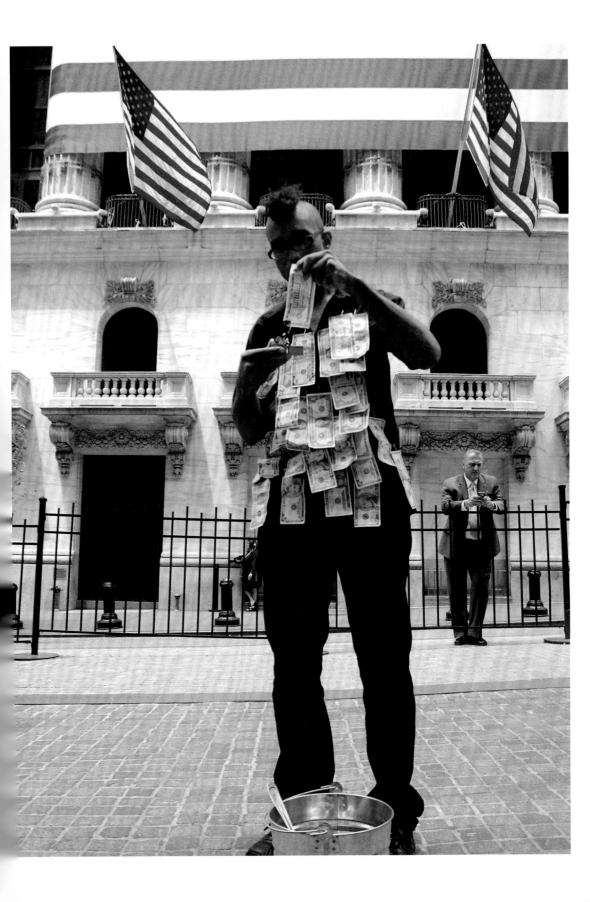

7a

Comments on Art from the Exhibition It's the Political Economy, Stupid

Thom Donovan

Dread Scott
Oliver Ressler and Zanny Begg
Alicia Herrero
Damon Rich
Julia Christensen
Filippo Berta
Field Work
(Lise Skou and Nis Rømer)

Oliver Ressler and Gregory Sholette's exhibition *It's the Political Economy, Stupid*, offers a diverse range of approaches to the problem of how artwork can both address and intervene in the intensified crises of finance capital. What is striking across these works, which use photography, animation, video, installation, and even the professional conference as their media, is how many of them perform an educational function, seeking to make legible and accessible complex socioeconomic forces. This is especially true in the works by Damon Rich, Oliver Ressler and Zanny Begg, and Alicia Herrero, all of whom attempt to create spaces of dialogue between economic and cultural leaders. Other works, like those by Dread Scott and Filippo Berta, rely on the documentation of poignant symbolic actions in social space to have their effect.

In a video of **Dread Scott**'s performance work, *Money to Burn* (2010), one sees Scott burning money (US dollar bills, tens, and twenties) while carrying a tin pail, stirring the ashes as he walks up and down Wall Street. He wears money on his chest, as though it were a fashion accessory or vestige. Passers-by watch

him with both curiosity and apprehension, as he invites them to burn their money. Few do. The video culminates when the NYPD stop to question him and seem to offer him some type of citation. There are few things perhaps more taboo than burning money. In doing so, one reveals money to be a kind of abject substance linked to bodily function – or perhaps the excrescent functions of the social body? Scott seeks to make visible, albeit on a considerably smaller scale, what financiers have been doing with public monies for years. Only whereas this activity is normally occluded by the practices of financial speculation, it reappears through the immolation and eventual disappearance of its physical substance. Ashes are what remain. And the doleful refrain "money to burn," which Scott repeats as he strolls Wall Street.

12

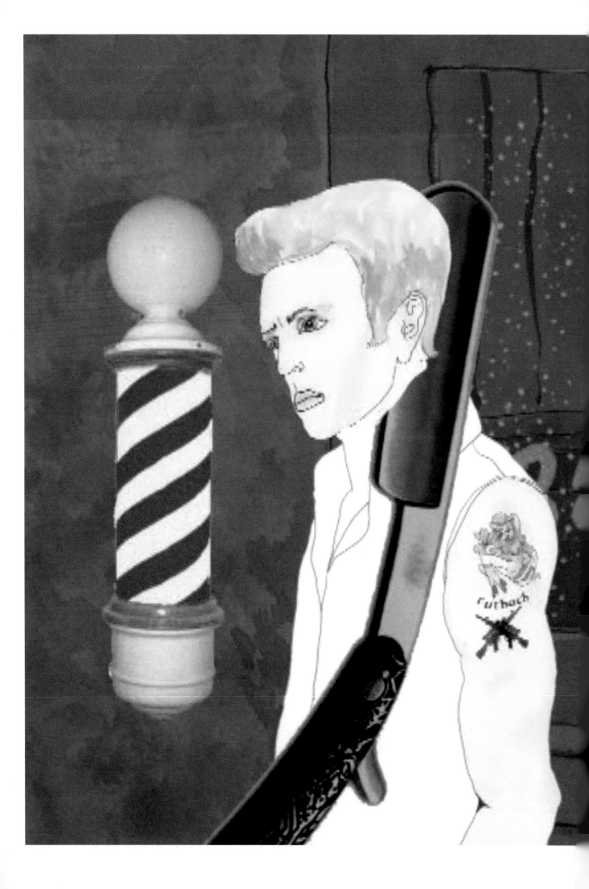

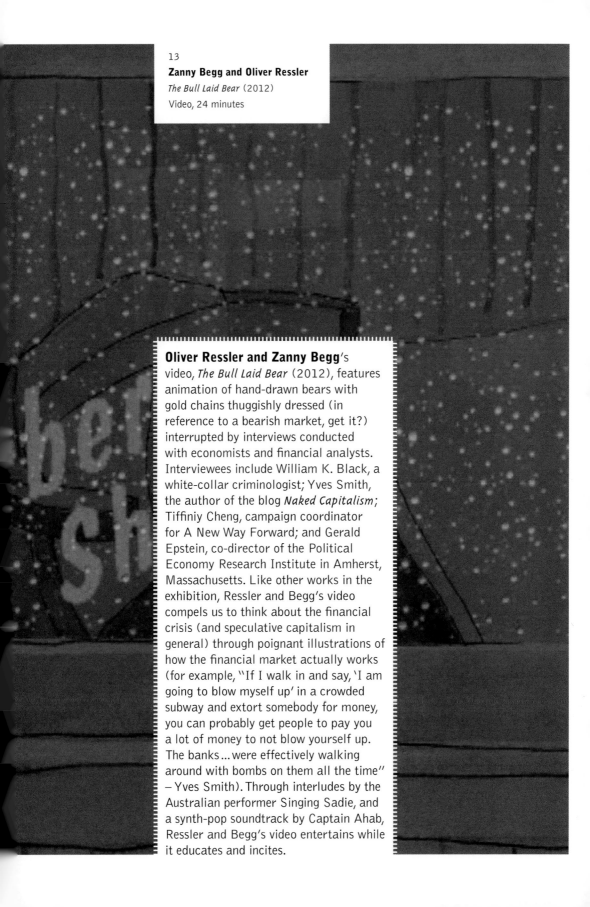

13
Zanny Begg and Oliver Ressler
The Bull Laid Bear (2012)
Video, 24 minutes

Oliver Ressler and Zanny Begg's
video, *The Bull Laid Bear* (2012), features
animation of hand-drawn bears with
gold chains thuggishly dressed (in
reference to a bearish market, get it?)
interrupted by interviews conducted
with economists and financial analysts.
Interviewees include William K. Black, a
white-collar criminologist; Yves Smith,
the author of the blog *Naked Capitalism*;
Tiffiniy Cheng, campaign coordinator
for A New Way Forward; and Gerald
Epstein, co-director of the Political
Economy Research Institute in Amherst,
Massachusetts. Like other works in the
exhibition, Ressler and Begg's video
compels us to think about the financial
crisis (and speculative capitalism in
general) through poignant illustrations of
how the financial market actually works
(for example, "If I walk in and say, 'I am
going to blow myself up' in a crowded
subway and extort somebody for money,
you can probably get people to pay you
a lot of money to not blow yourself up.
The banks…were effectively walking
around with bombs on them all the time"
– Yves Smith). Through interludes by the
Australian performer Singing Sadie, and
a synth-pop soundtrack by Captain Ahab,
Ressler and Begg's video entertains while
it educates and incites.

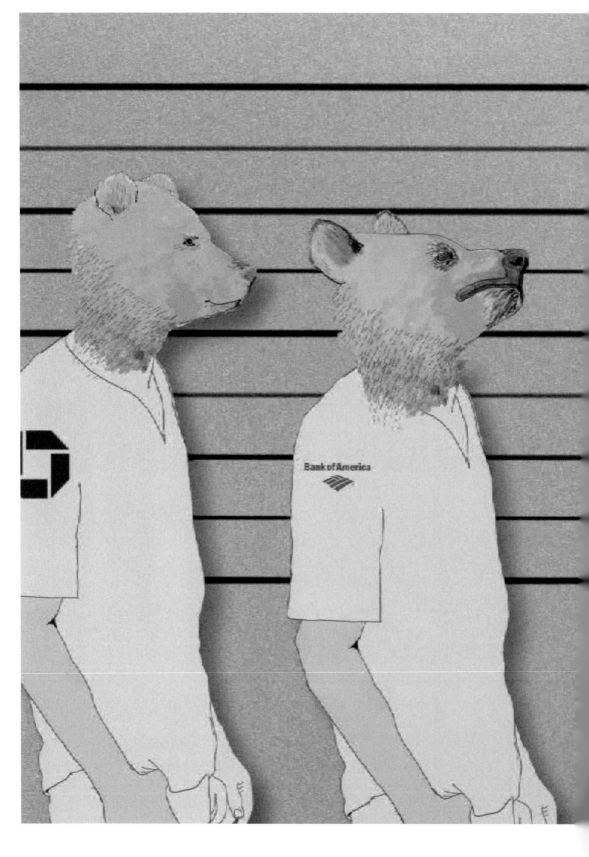

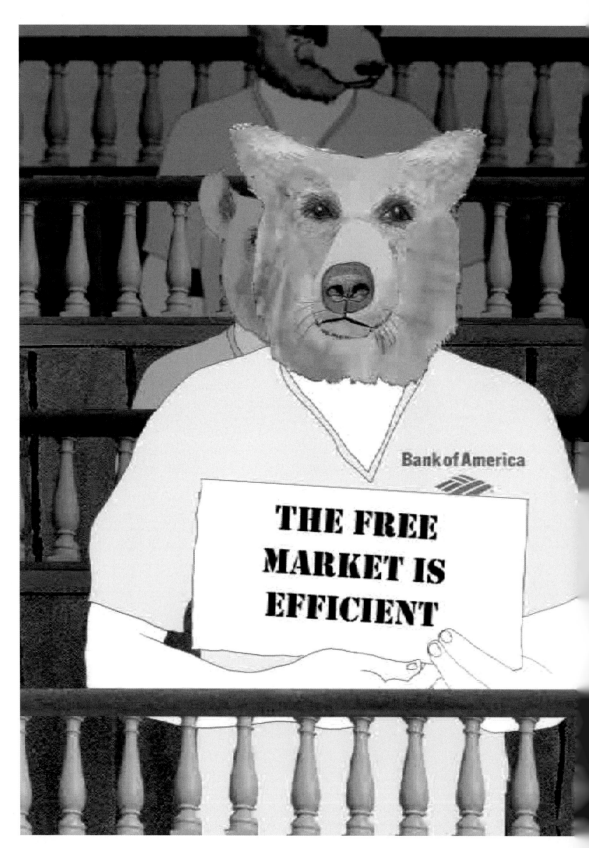

14
Alicia Herrero
Bank: Art & Economics (2011)
Video, 40 minutes

Alicia Herrero's video, *Bank: Art & Economics* (2010), features a conference in Buenos Aires that brought together economists, artists, and public intellectuals to reconsider the financial crisis through a Marxist economic lens and through aesthetic responses to the crisis. In one presentation, an economist discusses the causes of the eclipse of Marxist economics, historicizing them through the fall of Soviet/Eastern Bloc Communism. In aother, an artist discusses her efforts to produce bar codes so that people can purchase items at stores without having to pay for them. The conference is site-specific in its investigations of global neoliberal hegemony inasmuch as it, in Herrero's words, "takes place precisely on the iconic social capital, in a space of care, management and delivery of public money in the National Bank of Argentina, center-house at the legendary Plaza de Mayo in Buenos Aires City icon." Reappropriating the (quasi-)academic conference as a format for presentation and debate, it models how the format can be used counter-hegemonically within the framwork of "visual art." Wrinkles in the format – such as the use of a band to provide segues and to highlight speakers' key points – dramatize an alternative space for discourse and knowledge distribution.

Some neolibera
the bankers w

ay that perhaps

e very greedy,

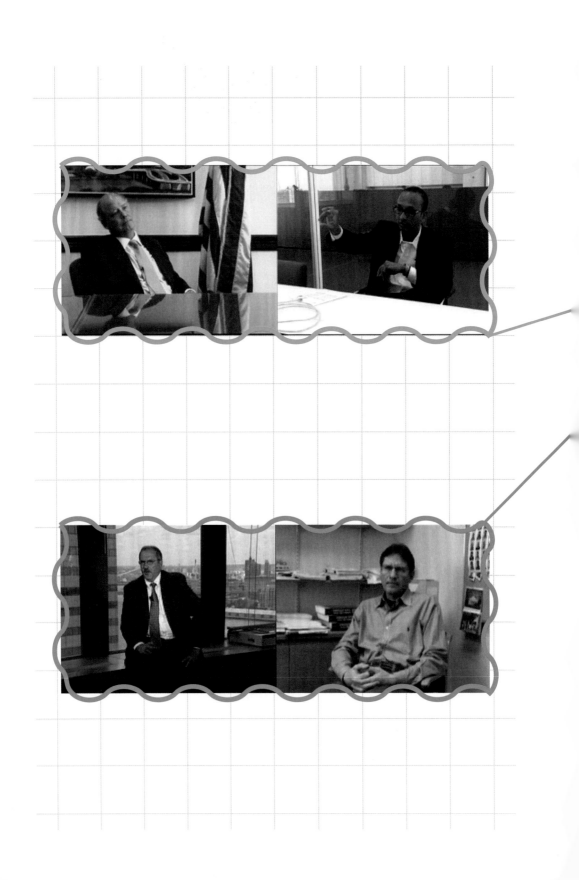

15
Damon Rich
Mortgage Stakeholders (2008)
Two-channel video, 47 minutes

Red Lines Housing Crisis by Center for Urban Pedagogy (CUP)/**Damon Rich** – exhibited coterminously at the Queens Art Museum – uses text, models, photographs, videos, and drawings to historicize the relationship between federal housing de/regulation and the real estate market in terms of the post-2008 housing crisis nationwide. This relationship originates in the policies of colonial state and federal US governments, who, as Rich writes in a text accompanying the exhibition, founded a legal environment in which property owners "hedge their bets" that tenants will not be able to keep up with their mortgages. *Red Lines Housing Crisis* shows how this systemic violence extends into post-war real estate literature and how citizens' groups fought effectively for legal reform against "red lining" – racial and class-based disinvestment strategies – in the 1970s. Rich's video *Mortgage Stakeholders* (2007–08) brings together bankers, regulators, architects, investors, financial justice advocates and others to discuss the current situation of real estate with regards to deregulation and economic injustice. Like other works in the exhibition, it attempts to offer a space for dialogue among a range of disciplines that do not typically converse. In the spirit of CUP's mission, the video offers analyses of complex political and social problems in a refreshing and accessible manner.

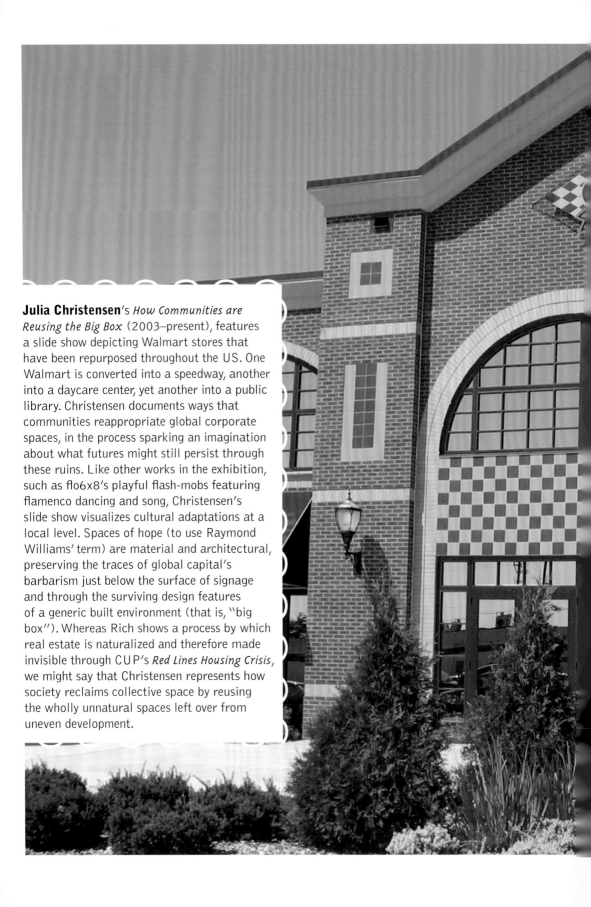

Julia Christensen's *How Communities are Reusing the Big Box* (2003–present), features a slide show depicting Walmart stores that have been repurposed throughout the US. One Walmart is converted into a speedway, another into a daycare center, yet another into a public library. Christensen documents ways that communities reappropriate global corporate spaces, in the process sparking an imagination about what futures might still persist through these ruins. Like other works in the exhibition, such as flo6x8's playful flash-mobs featuring flamenco dancing and song, Christensen's slide show visualizes cultural adaptations at a local level. Spaces of hope (to use Raymond Williams' term) are material and architectural, preserving the traces of global capital's barbarism just below the surface of signage and through the surviving design features of a generic built environment (that is, "big box"). Whereas Rich shows a process by which real estate is naturalized and therefore made invisible through CUP's *Red Lines Housing Crisis*, we might say that Christensen represents how society reclaims collective space by reusing the wholly unnatural spaces left over from uneven development.

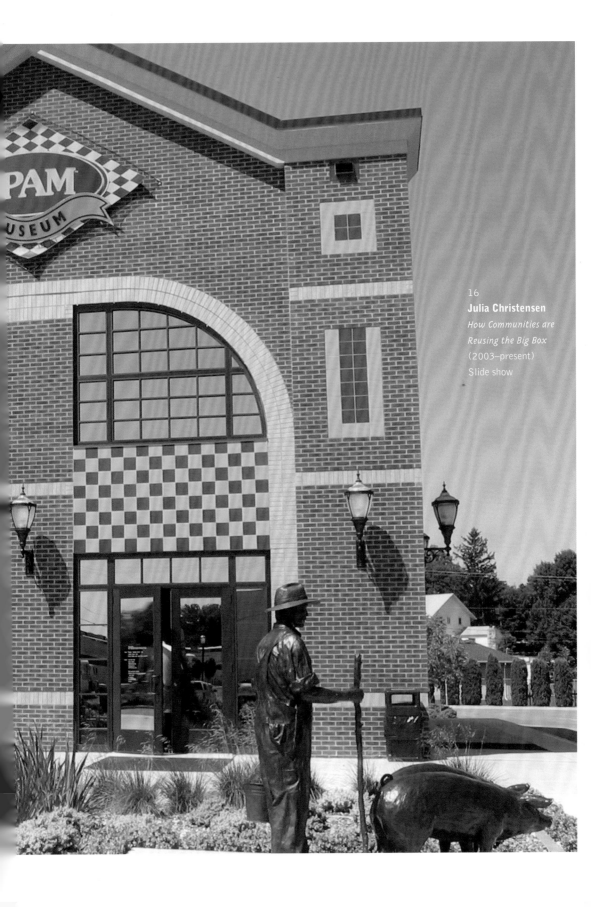

16
Julia Christensen
How Communities are
Reusing the Big Box
(2003–present)
Slide show

Filippo Berta
Homo Homini Lupus (2011)
Video, 3 minutes

Filippo Berta's video, *Homo Homini Lupus* (2011), features a pack of wolves in a barren landscape, fighting over an Italian flag. Undoubtedly allegorical (global financial capital uses particular nation states to institute laws that exploit property rights and labor), what is compelling about the video is the positioning of the camera dangerously close to the action and the choppy editing which amplifies the violence of the wolves battling over a extremely limited territory. Aptly, the title comes from the Roman satirist, Plautus, and translates from Latin to English as "man is a wolf to man." The three-minute video concludes when the flag has been utterly soiled and tattered by the competing wolves.

In the above works, art functions both symbolically and through strategic actions to produce active reflection about the causes and repercussions of the 2008 global financial crisis that has called neoliberal policies dramatically into question. Through bold gestures, as in Berta's, Christensen's, and Scott's works, they reveal a truth content of current economic conditions. As in the case of CUP/Rich's project and Ressler/Begg's, they are also not afraid to explore forms of documentary and educational platforms that may empower an audience to explore the various contradictions of financial capital on their own.

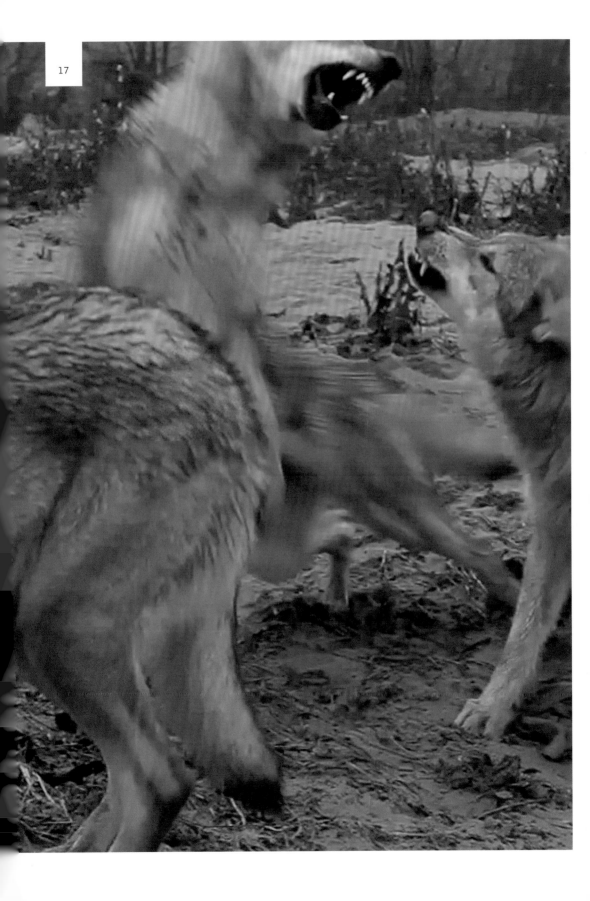

18
Field Work: Lise Skou and Nis Rømer
Revenge of the Crystals
(2012)
Video, 25 minutes

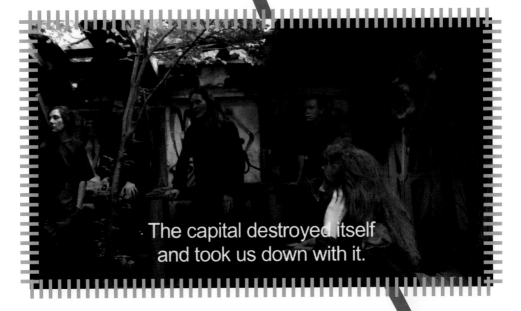

We need to create communes
in different parts of the world –

Let's discuss the purpose of the
cooperative. What do we want it to be?

18

Field Work is a two-person group made up of the Danish artists Lise Skou and Nis Rømer. Their most recent video piece, *The Revenge of the Crystals*, is a five-part fictional narrative set in the aftermath of the present financial collapse. It is a moment in the near future when the failing global monetary system has destroyed almost every institution, and the decay of society has become a habit where few alternative visions exist. The short film depicts the aftermath of a revolution in which a small collective of people form a fragile commune in a garden. We see them learning the basic skills of survival and ways of living together. Step by step they fight to stay alive, attempting to do so without sacrificing their intellects or sense of solidarity. While focusing on the complexities of organizing a world that now resembles Giorgio Agamben's notion of "bare life," Skou and Rømer's carefully-scripted piece nonetheless manages to address underlying issues of politics, philosophy, and aesthetics that are all too relevant to our present-day circumstances of unrelenting economic crisis, authoritarian drift, and rapidly failing states.

We won't b
to our

Sick Sad Life:

On the Artistic Reproduction of Capital[1]

Kerstin Stakemeier

"On a photograph, as it were, capital always just looks like money."[2]

The disappointment which resonates in Alfred Sohn-Rethel's formulation is all too understandable. Artistic attempts to represent capital figuratively, and in Sohn-Rethel's example from the early 1970s in the seemingly most trustworthy visual medium, photography, are doomed to failure.[3] Being the social relation on which all of our reproduction is based, guiding the ubiquitous law of form, including even that of the camera which records the image, capital itself is still, or rather therefore, aniconic. It signifies an order of production, which imprints itself in everything, and therefore has itself no singular image. Because "within circulation M-C-M [money—commodity—money]...both, commodity and money, only subsist as different forms of existence of value itself, money as its general, the commodity as its specific disguised forms of appearance."[4] Both are reified forms of capital, but are bound to the sphere of distribution — in contrast to that of production. Picturing money thus remains, even though it is the general exchange equivalent, no more than a helpless gesture, a reference to that capitalist form of value, which concerns everything within the picture in any case. The disappointment ultimately lies in the fact that one faces just another reified form of value. But capital would need to be criticized by its objectives, not by its equivalents, which in the end are no more than things amongst things. What turns those things into problems is that it expedites a process at the end of which there is no end, but only the reproduction of that very relation which needs the exchange of equivalents for its continued existence: capital.

*The true limit of capitalist production is capital itself, it is this: the fact that capital and its **reproduction** appear as starting as well as endpoint, as motives and as means of production; that production itself is **for** capital and that its means of production are not just the means of the ever expanding exploration of the life of the society and its producers.*[5]

Commodities, just as the queen of commodity itself, money, are just those points in the process at which production materializes for a brief moment, emerging to be exchanged, only to return to the value form as a result of that exchange shortly thereafter. What Sohn-Rethel wants photographed is thus first and foremost a relation of reproduction, and money is not a specifically productive starting point for the dissemination of that relation. It is the level of reproduction, the moment in which money, for good and for bad, is conspicuous by its absence, in which that power which capital still is remains imprinted. In the reproduction of capital that of human kind is concealed, and in the relentless returns of the "so-called primitive accumulation"[6] it is not only the means of reproduction of capital itself, which are intensified and expanded, but simultaneously the function of human kind within it is defined as that of a means to an end:

The process, therefore, that clears the way for the capitalist system, can be none other than the process which takes away from the laborer the possession of his means of production; a process that transforms, on the one hand, the social means of subsistence and of production into capital, on the other, the immediate producers into wage laborers. The so-called primitive accumulation, therefore, is nothing else than the historical process of divorcing the producer from the means of production.[7]

As Rosa Luxemburg and others have argued in Marx's succession, this process is not simply the historical myths of capital's origin, in which the world was created after its model, but this process, the violent clearing of different spheres of production, is proceeding continuously. Within art the advancement of such primitive accumulation could be explicated in the creation of modern art and that of contemporary art by capital.

With the "formal subsumption"[8] of art under capital in the nineteenth century, art was established as a sphere of production differentiated from artisanal crafts in which, however, the conditions of production initially remained the same (a factor that became known as "autonomy"). The "real subsumption" of art under capital after the Second World War, the institutionalization of contemporary art as a segment of industrial mass culture, was based on those factors. Within this field of contemporary art, education, production, distribution, and representation are arranged after the model of the cultural service sector and thus have performed an ongoing "primitive accumulation" of autonomous art, establishing a standard, which implies the de facto de-autonomization of artistic production but thereby coincides with its factual politicization. As an industry, art lost its unwanted unaccountability that had been the price of its autonomy.

Consequently, capital is as over-represented and alternativeless in art as it is in all other spheres of production and reproduction. All creative attempts to gain as much distance to capital as to fit it into a frame are ineffectual, as they would need to represent that person taking the image herself as a figure of capital. Artists are above all producers within the sector of mass culture, and their exceptional position within it today almost seems like a scornful repetition of pathetic formulas of autonomy in which that force which characterizes the working conditions within the sector, underpayment, institutional and personal dependencies, a lack of social communization and means to organize are hitting back unfiltered. Autonomy has turned into the scheme of a classicized utopian past tense, it represents an institutionalized icon and not the heteronomous praxis of contemporary artists. Some art-based organizations including the group WAGE (Working Artists and the Greater Economy) have been confronting these very

conditions by directing critical questions of organization to cultural *institutions* (as opposed to artist producers). This approach, for better or worse, maintains the model of autonomy as the well-known social formula for being an artist in the first place but refuses the projection of the genius artist as heroic agitator. In WAGE the capacity for organization thus does not lie primarily in the direct address of individualized artists-against-institutions, but derives power if anything from this very sense of an anonymized unit that discloses its own conditions of production and reproduction. Founded in 2008, WAGE have been concentrating their efforts on enforcing "the regulated payment of artist fees by non-profit organizations and museums"[9] since 2010. For this purpose they have been working on a certificate which institutions can sign as a voluntary commitment to this "best practices model."

Our own reproduction within capital weaves us tightly into a curtain which we cannot simply tear away, because behind it there is nothing but another view onto M-C-M. This is not to say that I am arguing that we are caught up in a situation void of alternatives, but rather that the visual repetition of capital in its "naturalized environment" promises nothing more than a moralistic naturalism, or simply opens a view onto a general exchange value. And the latter has never been more adequately staged than in Scrooge McDuck's money bin. Artistic attempts to reverse this relation, to demonstrate money as capital in comparison are trapped in the sphere of exchange: Lee Lozano's *Real Money Piece* (1969), in which she offered her guest "diet Pepsi, bourbon, glass of half and half, ice water, grass, and money. Open jar of real money and offer it to guests like candy,"[10] demonstrates nothing more that the social dealings with a medium of general exchange which itself carries no use-value. One year later, in 1970, Cildo Meireles printed messages onto money bills and Coca-Cola bottles, exposing how they both circulated within the same field, within the national borders of Brazil, and thus marked this movement of circulation in its expansion and limitation. In his *Insertions into Ideological Circuits*, Meireles attempted to reify money itself, which necessarily failed, but could only personalize the visage of the ever-recurring forms of M-C-M. And it is precisely this which makes Scrooge McDuck's money bin so "priceless": he projects that commodity fetishism which effortlessly identifies Pepsi, Grass, tagged Cola bottles or the camera mentioned above, onto the very sole commodity which socially operates as a medium only, and thus allows no personalization. Countless Hollywood movies have repeated this motif, and in 1987 Allan Kaprow laid out a *Red Carpet for the Public* at *Documenta 8*, putting up for grabs the money he was given to realize his work. But all of these momentous rededications of money, its partial redistribution as much as its pointed fetishization, are collapsing outside of Duckburg, because they inevitably end up in the circulation, as money remains the sole general means of exchange. Artistic assaults on money

are countless but their necessary limitation lies in its symbolic negation, replacement, or qualification, which all remain views onto an abstraction, which has no chance of turning into one of concretion.

For WAGE, money does not appear as the center of artistic or political debate but as that general exchange value which is needed to secure one's reproduction. And it is thus this reproduction which takes the center stage of artistic and political debate – the social and material cornerstones of one's own survival in the industrial branch called contemporary art. The economic differentiation of this branch filtered just as much into the organization structures of artists such as Lee Lozano and others who founded groups like AWC (Art Workers' Coalition) in the late 1960s, as they were claiming more power over their institutional representation and denounced the substantial exclusion of women, African American, and Puerto Rican artists in the large institutional collections in New York. It is the real subsumption of artists under capital which transforms them into producers of contemporary art. And it is this process that in turn gave rise to the independent artist organizations of the 1960s and 1970s, while implicating artists in the dramatic social struggles of their time, including most notably the anti-Vietnam War movement. They participated in these political confrontations as one kind of "producer" amongst many. Consequently, the capitalization of art also meant its factual socialization. And it is not entirely coincidental that with the worldwide uprisings of 1968 a new understanding of one's own integration within capital evolved, an "inside view," which Gilles Deleuze reformulated in 1969 in an actualization of the most classical model of Marxist ideology critique:

If there is nothing to see behind the curtain, it is because everything is visible, or rather all possible science is along the length of the curtain. It suffices to follow it far enough, precisely enough, and superficially enough, in order to reverse sides and to make the right side become the left or vice versa.[11]

And it is precisely in this model that we find that the Marxist disappointment about the seeming lack of formal strength in the artistic practices of the 1970s is in itself reactionary with respect to the reality of those artistic practices: the modernist framing of the artwork, which is implied in Sohn-Rethel's search on the surface of the photograph, sees art in exactly that constrained "autonomous" isolation as characterized by pre-war art in its only formal subsumption under capital. Sohn-Rethel hopes that art will tear away the curtain, whilst it had long been woven into its structure, though gaining a new politicality in the process. The artistic social utopianism of the 1920s could still depict money as an external factor, as an ideogram of capital without falling prey to sheer naturalism. John Heartfield's hilarious collages

demonstrate this point trenchantly. But as Sohn-Rethel brushes aside the material reorganization of contemporary art as a form of capital, its existence as a branch of the cultural industry, he expects art to create an unreal view, to conform to the bourgeois pretention of its lost autonomy.

Notes

1. This chapter was originally written for *Bildpunkt*'s (autumn 2012) issue on money. *Bildpunkt* is the magazine of the IG Bildende Kunst Austria. The text is translated by the author and reprinted here with kind permission of the author.
2. Alfred Sohn-Rethel, "Der Formcharakter der Zweiten Natur," in Alfred Sohn-Rethel, Peter Brückner, Gisela Dischner Peter Gorsen, et al., *Das Unvermögen der Realität: Beiträge zu einer anderen materialistischen Ästhetik*, Berlin: Klaus Wagenbach Klaus, 1974, p. 198.
3. Alfred Sohn-Rethel was a Marxist political theorist and economist (1899–1990), who was a friend of Ernst Bloch and Walter Benjamin and ongoingly discussed his lifelong working project *Geistige und körperliche Arbeit* (Intellectual and Manual Labor; first published by Suhrkamp in 1972) with Theodor W. Adorno. In it he delineates the genesis of knowledge and abstract thought in relation to that of the capitalist value form, the commodity and money. The book I quote from was published by him and others in 1974 and can be seen as a directly opposite standpoint to Peter Bürgers' *Die Theorie der Avantgarde* (The Theory of Avant-Garde) published the same year. The above-quoted take on a productivist and feminist perspective against the grain of the Marxist aesthetics of Bürger and Adorno, but, only in Sohn-Rethel's case, still adhere to a classical ideal of art.
4. Karl Marx, *Das Kapital*, Bd. 1, MEW Bd. 23, Berlin, 1982, p. 168f.
5. Ibid., Bd. 3, MEW Bd. 25, Berlin, 1990, p. 278.
6. Ibid., Bd. 1, p. 742.
7. Ibid.
8. Karl Marx, "Resultate des unmittelbaren Produktionsprozesses," Archiv sozialistischer Literatur 17, Neue Kritik, Frankfurt am Main, 1968, pp. 46ff.
9. http://www.wageforwork.com/about/3/history.
10. http://www.e-flux.com/projects/do_it/manuals/artists/l/L002/L002C_text.html.
11. Gilles Deleuze, *Logic of Sense*, London and New York: Continuum, 2005, p. 12.

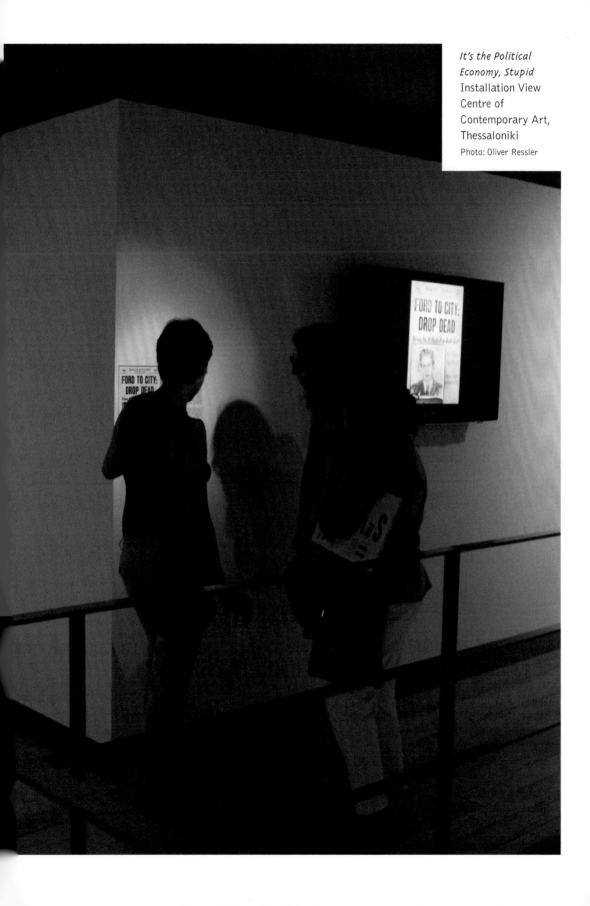

It's the Political Economy, Stupid
Installation View
Centre of
Contemporary Art,
Thessaloniki
Photo: Oliver Ressler

9

Art
After
Capitalism

Brian Holmes

Many came to the conclusion long ago:
art after capitalism starts right now.

Passionate conversations about how things will look once socialism is achieved are rare in our day. Instead, transformations are undertaken with the means on board, for results that can be shared, distributed, and adapted by others. Utopia consists of changing something real, whatever the scale. Great things have happened this way and we'll see more in the future. But the massive fact of capitalism's persistence in the present continually returns to complicate, hinder, obstruct, or paradoxically encourage artistic experiments that have flowered on common ground.

The first steps toward a post-capitalist practice involve the redefinition of art itself. Call it anti-art, the overcoming of art, art into life, the aesthetics of existence: all these formulations represent a major inheritance of the twentieth century. The crucial insight of what were formerly called the "avant-gardes" is that an image of emancipation provides only a contemplative respite from exploitation, hierarchy and conflict. The energies devoted to the creation of a privileged object could be better spent on reshaping the everyday environment. Abandonment of the authorial form and exodus from the museum are some consequences of these vanguard insights. A protean world of exploration and intervention opens up for practitioners of art into life. If you take this path you will often hear the complaint that artists these days just can't "handle the brush" as their predecessors did. Yet it's up to us to demonstrate that there are other ways of unfolding formal complexity into lived experience.

Processual art explores the generative roots of any collaborative activity, seeking not only the inventive twist that departs from a normal, pre-codified way of doing, but also the synaptic or affective leap that allows another person to appropriate that invention, to develop it further and pass it along among a crowd. In the best of cases a rhythm emerges, with the sense of a shared horizon. We're all familiar with the feelings of bodily exuberance and sociable pleasure that arise in games; but this kind of play is also constructive. The specific character of "art" might be hard to locate when people are building a community center, planting a garden, preparing a meal, writing a text together, or just talking around a table. Yet all this is fundamentally part of art after capitalism. Of course, images of such activities can be extracted and displayed as the simulacrum of a missing fulfillment ("relational art," they call it). But the point of the post-capitalist process is to develop new means of production, where subjectivity — the group itself in its affective and collaborative pulse — is the primary thing we produce together.

On that basis, much can follow. I'm thinking about the creation and distribution of sophisticated works, like installations, performances, films, and interactive media, which condense broad swathes of experience into intensive little packages. In fact, these kinds of aesthetic objects have much to contribute to life in a complex society. The problem is not so much their form, as their destiny under capitalism. All those involved in contemporary culture

are familiar with highly conventional presentations before a presumptively neutral audience: a museum show, a lecture, a screening, a staged event, a publication, and so on. Under these conditions, the evaluation of the work takes place according to a few restrictive criteria. First comes the "interest" or advantage that a given work may hold for each spectator, as a source of new ideas, encouragement, or sheer personal pleasure. Then there is a more envious speculation on the interest the work may hold for others, so that publicly claiming it as one's own object of desire establishes tacit ties of allegiance with them. A third very common mode of evaluation is strictly negative. Attack, ridicule, and disdain are typical strategies in the cultural marketplace of ideas. The capitalist economy is defined as the "art of allocating scarce resources" — so, naturally enough, the formal public sphere is a space of intense competition. This struggle for primacy is one of the big dead-ends of art in today's society. The production of a cooperative community opens a new door.

Multi-layered works are developed slowly, through complex processes of perception, self-reflection and expression that always involve more than one person. Their use-values can only be discovered over time, through contact, immersion, dialogue, reference, response, and reworking. Traditionally (in what was known as "bourgeois culture"), this inherently social process of discovery was internalized by individuals, who experienced a work in silence and let aspects of it cohere in the intimacy of their memories, as a kind of vibrant inner beacon to which they would return from time to time. Reception by a cultural community brings out the latent dimensions of this traditional schema. The first stage of this process involves direct response and sustained dialogue in informal settings, unencumbered by time constraints or conventional protocols that limit the circulation of speech. Usually the work itself can then be shared, through copies, recordings, archives, or long-term presentations in everyday spaces, without the mediation of money and the obstacles it brings. Electronic networks vastly expand this distribution. Since the late 1990s community meshworks have stretched to the far corners of the globe, bringing a multitude of artistic expressions with them.

Access and immediate dialogue, however, are only the beginning. What's surprising is the way the sensations and ideas of the artwork resurface in later conversations, in other works, texts, projects or programs. Without disappearing, the figure of the author tends to disperse into appropriation and remix. Direct references to the content of a piece are less important than a lingering affective presence, a kind of memory echo that creates an aesthetic atmosphere. In capitalist society such atmospheres also exist: but they are engineered at a distance, according to instrumental calculations. In a cultural community the modulation of the environment by all the participants is the tacit act of creation that binds the group together and, in the best of cases,

extends an invitation for others to join. Sustaining a generous atmosphere is crucial for these communities of reception. We may be accustomed to thinking that prefigurative politics takes place in exceptional moments on the streets. But when a cultural scene stays under the radar, eluding the rules of money and defending itself against institutional manipulation while continually opening itself up to new people and new explorations, what it is developing is nothing other than the prefigurative politics of art after capitalism.

So how does this post-capitalist art relate to its more militant anti-capitalist cousins? What about subvertising, Indymedia, Luther Blissett, Critical Mass, corporate identity correction, border-hacking, communication guerrilla, and all the other activist inventions that have flourished since the 1990s? Do complex images, impassioned discussions, exquisite atmospheres, and the efflorescence of memory really have anything to do with speaking truth to power? How to cross the thin red line separating community art from art in the streets?

Every carefully executed work of perception-expression will reveal — perhaps unwittingly — an aspect of what Theodor Adorno called "damaged life." It's a basic condition of existence in our pathological societies. Art that emerges from centuries of capitalism can only be a symptom of this damage, until it opens itself up to an analytic process that helps us understand where it has come from. Analysis is often opposed to expression: it is considered a form of blockage or censorship of the affects. Yet this opposition serves the logic of entertainment, where aesthetic experience is conceived as nothing more than a hedonistic stimulant, bypassing the intellect for a direct connection to the senses. Among cultural communities whose participants have overcome the instrumentalization of art and its separation from daily life, analysis acts to heighten perception, to extend the horizons of language and to intensify our awareness of the tragic dimension from which solidarity draws its strength. Often, an artwork contains a demand for analysis: it sketches out a problematic field that can be explored by others. But this demand can only be embodied and expressed through an act of resistance. The red line is crossed when what we have seen and understood can no longer coexist with what we envision and ardently desire. As one reads on a series of works by Muntadas: "Warning: Perception Requires Involvement." There's no mystery why so many artists end up on the front lines of demonstrations and occupations.

The recent "movement of the squares" — in Greece, Tunisia, Egypt, Spain, the US, and many other countries — saw untold numbers of artists venturing out onto the streets, with their works, their performances, their subtle understanding of ambiances and crowd dynamics. Art on the streets is an expression of resistance, but it is also an invitation to change the ways we look, feel, think, act, and relate. This much is familiar from the occasional victories of the past, back when the notion of civil society still seemed to have

some meaning. But today, as new generations take up the struggles across the globe, the violence of the confrontations is matched only by the deafness of power to any voice but its own. The massive extension of protest and dissent carries new risks, and the stakes are rising with each fresh outburst of rebellion. Under such conditions one sees an upsurge of the healing arts among post-capitalist communities. I am thinking of massage and bodywork, but also of group experiments with expression and imagination, often involving precise aesthetic practices. No doubt some will scoff at this preoccupation, which could be mistaken for a narcissistic trap, redolent of a former counter-culture. Yet the current polarization of society and its violent consequences are not to be taken lightly. The idea that there can be a therapeutic dimension of art — a vital relation between expression and healing — is something that artists and thinkers should consider more seriously in a period of economic and ecological catastrophe.

Where will all this lead? The fact is, no one knows. The appearance of politicized art in institutional settings is merely a correlate of far wider upheavals. The artist graciously installing her drawing, film, or sculpture in the cool white spaces of a museum or gallery may be found the next day among the chanting crowd, making a banner, staging a protest choreography or shooting an agitational video to go out on the internet that evening. The presence of dissident artworks within the institution is not necessarily cynical. Artists working the official circuit often draw their material from the constructive play of cultural communities and the risky freedom of political insurgency, in order to transform the usual functions of a society in which they still necessarily participate. The hope is to vastly extend the avenues leading to an exit from a failed paradigm. Yet the rules of competition and money remain alive in the background; and it is important to learn how to struggle absolutely for changes that are still only partial. The persistence of a devastatingly inadequate system is the central fact of our time.

In conclusion: art after capitalism might sound like a joke, and maybe not a good one. In fact, I laughed out loud when I saw that the editors of this volume had proposed such a title for my contribution. On reflection, however, it seemed like they were onto something. It is not very often that one is asked to explain the meaning of an underlying idea that has become a path toward a whole way of living. We should always seize the occasions that are offered to cast our existence in a different mold — since the point is not to be the author of one's own private universe. Art after capitalism only begins when we find new ways to work together.

Besides, laughing out loud can be good for you.

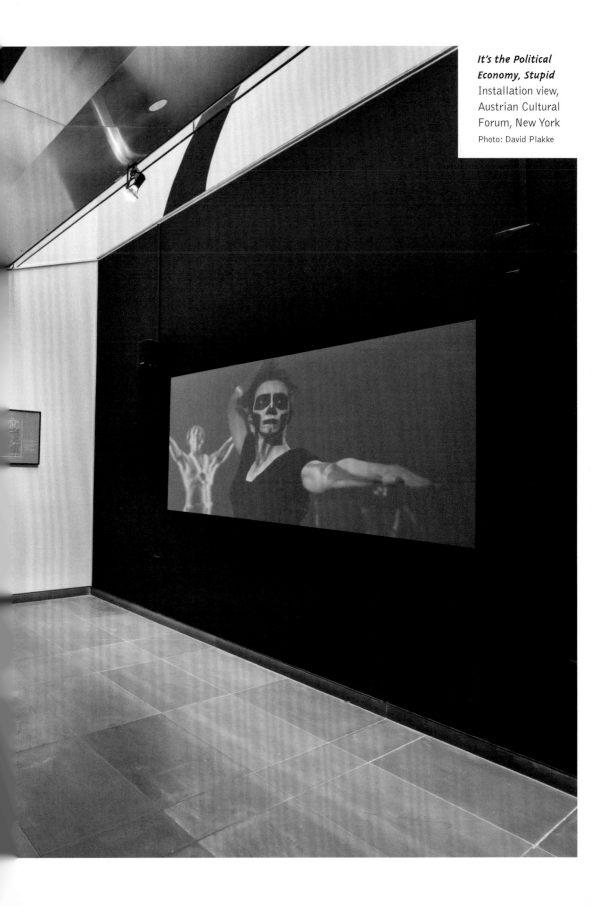

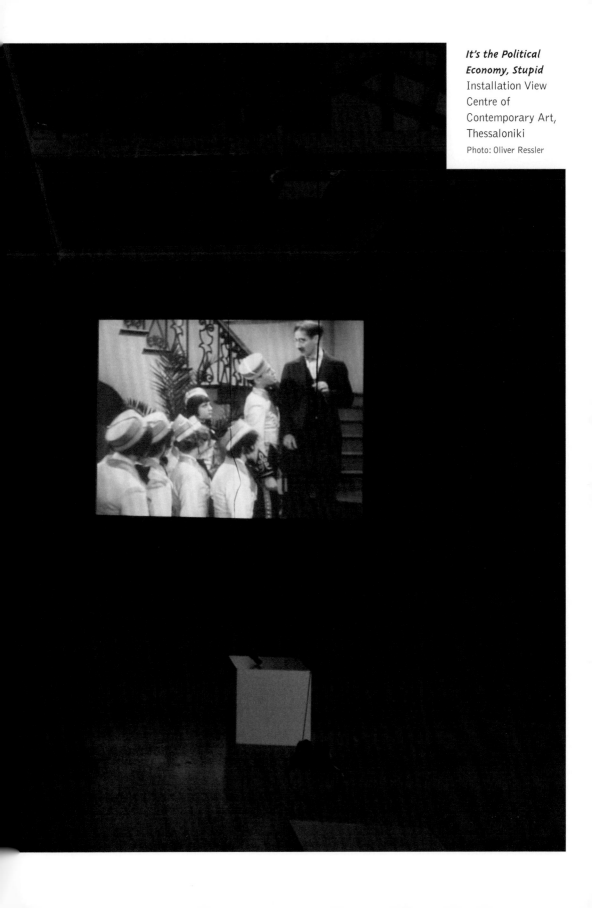

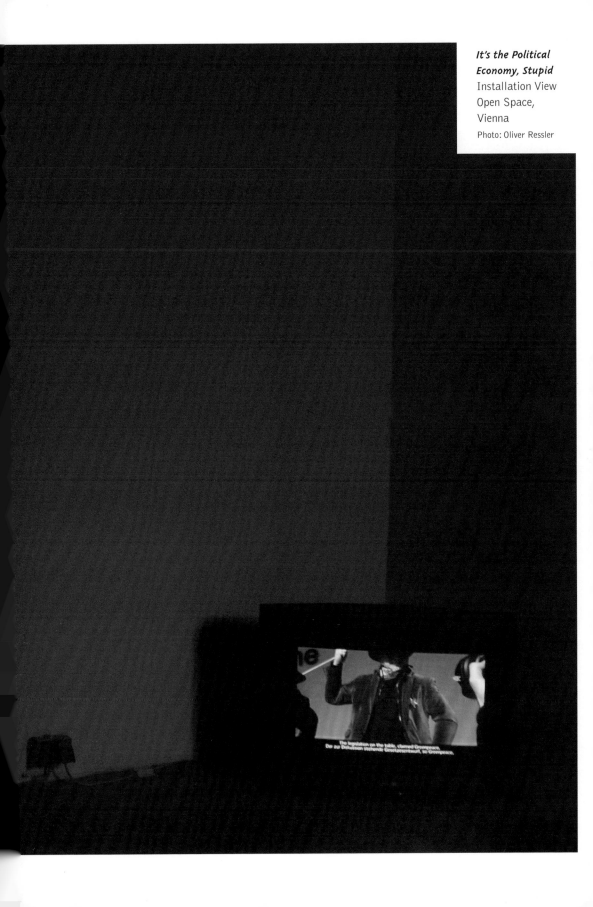

*It's the Political
Economy, Stupid*
Installation View
Open Space,
Vienna
Photo: Oliver Ressler

It's the Political Economy, Stupid

TOURING EXHIBITION

Open Space – Zentrum für Kunstprojekte, Vienna
http://www.openspace-zkp.org
16 March–25 April, 2011
Participating artists:
Zanny Begg
Libia Castro & Ólafur Ólafsson
Damon Rich
Superflex

Austrian Cultural Forum, New York
http://www.acfny.org
24 January–22 April, 2012
Participating artists:
Linda Bilda
Julia Christensen
Reading Lenin with Corporations
flo6x8
Melanie Gilligan
Jan Peter Hammer
Alicia Herrero
Institute for Wishful Thinking
Zanny Begg & Oliver Ressler
Isa Rosenberger
Dread Scott

Centre of Contemporary Art in Thessaloniki, Greece
http://www.cact.gr
June 27–October 14, 2012
Participating artists:
Filippo Berta
Linda Bilda
Julia Christensen
Reading Lenin with Corporations
flo6x8
Melanie Gilligan
Jan Peter Hammer
Alicia Herrero
Institute for Wishful Thinking
Sherry Millner & Ernie Larsen
Libia Castro & Ólafur Ólafsson
Zanny Begg & Oliver Ressler
Isa Rosenberger
Dread Scott

Pori Art Museum, Pori, Finland
http://www.poriartmuseum.fi
February 1–May 26, 2013
Participating artists:
Filippo Berta
Julia Christensen
Field Work
Reading Lenin with Corporations
flo6x8
Melanie Gilligan
Jan Peter Hammer
Alicia Herrero
Institute for Wishful Thinking
Sherry Millner & Ernie Larsen
Libia Castro & Ólafur Ólafsson
Zanny Begg & Oliver Ressler
Isa Rosenberger
Dread Scott
Superflex

CCA Derry-Londonderry, Northern Ireland
http://cca-derry-londonderry.org
2014
*Please visit the webpage for details about this
and all future shows.*

NOTES ON
CONTRIBUTORS

Zanny Begg was born in Melbourne, Australia, and lives and works in Sydney, Australia. Her work revolves around an investigation of the politics of space, both in the broader globalized context and a more specific local one: she is interested in both the architecture of space and the social relationships that construct it. Zanny works in a cross-disciplinary manner as an artist, writer, and curator. She is currently the Director of Tin Sheds Gallery and her exhibitions include Istanbul and Taipei Biennial.
http://www.zannybegg.com

Filippo Berta was born in Bergamo, Italy, and lives and works in Bergamo. He analyzes the tensions inherent in the individual and in social relations, interpreting them as dualistic forms. He has exhibited at the MADRE Museum of Naples; National Brukenthal Museum of Sibiu, Romania; Prague Biennale V Edition, and Moscow Biennale for Young Art III Edition. He won the IV Edition of the International Prize of Performance of Trento, Italy.
http://www.filippoberta.blogspot.co.at

Linda Bilda was born in Vienna, Austria, and lives and works in Vienna. Bilda is an artist and inventor. She was the co-editor of *Art Fan* and the political art magazine *Die weiße Blatt*. Her artwork on comics (No comics), sculptural work, and murals focus on the economy, capitalism, and the nation state, while challenging the underlying corruption that takes place in our day-to-day lives.
http://www.thegoldenworld.com

Julia Bryan-Wilson is Associate Professor at the University of California, Berkeley, where she focuses on modern and contemporary art, in particular post-war art, feminism, queer theory, performance, craft histories, video, artistic labor, and collaborative practices. Her book *Art Workers: Radical Practice in the Vietnam War Era* was published in 2009, and she is the editor of the forthcoming *October Files* volume on Robert Morris. Julia's writing has appeared in the *Art Bulletin*, *Art Journal*, *Artforum*, *ArtUS*, *Bookforum*, *Cabinet*, *Camera Austria*, *Camera Obscura*, *Differences*, *Frieze*, *Grey Room*, *October*, the *Journal of Modern Craft*, and the *Oxford Art Journal*.

Judith Butler, PhD, Hannah Arendt Chair at the European Graduate School EGS, attended Bennington College and then Yale University, where she received her BA, and her PhD in philosophy in 1984. Her first training in philosophy took place at the synagogue in her hometown of Cleveland. She taught at Wesleyan and Johns Hopkins universities before becoming Maxine Elliot Professor in the Departments of Rhetoric and Comparative Literature at the University of California, Berkeley.

Libia Castro and Ólafur Ólafsson have been working collaboratively since 1997 and live and work in Berlin and Rotterdam. Working in a variety of media, the pair's work explores the relationships between art, everyday life, sociopolitical, economic, and cross-cultural issues. Among others they represented Iceland at the 54th Venice Biennial (2011), exhibited in Momentum-Nordic Biennial (2009), *Manifesta 7* (2008), the 8th Havana Biennial (2003), and were awarded third prize in the Prix de Rome (2009) in the Netherlands for their video work *Lobbyists*.
http://www.libia-olafur.com

Julia Christensen was born in St. Louis, Missouri, USA, and lives and works in Oberlin, Ohio, USA. Julia Christensen is a multi-disciplinary artist whose work explores systems of consumerism, community, landscape, and history. Christensen is Assistant Professor of Integrated Media in the Studio Art Department at Oberlin College, where she also serves on the faculties of environmental studies and TIMARA (Technology in Music and Related Arts).
http://www.juliachristensen.com

Angela Dimitrakaki is Lecturer in Modern/Contemporary Art at the University of Edinburgh. She holds a BA in archaeology and art history from the University of Athens (1991), an MA in gallery studies from the University of Essex (1992), and a PhD in art history from the University of Reading (2000). She was Lecturer in Contemporary Art at the University of Southampton from 2001 to 2006. Angela's research is in the field of contemporary art history and theory. It involves a wide range of practices, with a greater emphasis on lens-based media and participatory paradigms, and examines the social processes and structures that determine the production of meaning in contemporary art practice, often with a particular focus on developments in Europe.

Thom Donovan lives in New York City where he works as an archivist, educator, and writer. His first full-length book of poems, *The Hole*, is available with Small Press Distribution in Oakland. He is currently a professor at the School of Visual Arts and at Parsons. He also edits an online feature at Art21, "5 Questions for Contemporary Practice," regarding aesthetic politics and the artist's role in public discourse, and has edited a feature on "Poetry During Occupy Wall Street" for *Rethinking Marxism*.

Noel Douglas is an artist and designer who works across a range of media. His main interests are in the relationship between aesthetics and politics and creative use of graphics and art and design in social movements as part of a wider interest in designing for the Commons. He is a Senior Lecturer and Cluster Leader in Graphic Arts at the Division of Art and Design, University of Bedfordshire.
http://www.noeldouglas.net

Field Work (Lise Skou and Nis Rømer) was formed in 2006 to engage with issues of conflict and ways of survival. Their collaborative projects have been shown at Gentle Actions – Art, Ecology and Actions at Kunstnernes Hus, Oslo (2010), the 4th Bucharest Biennale (2010), the solo exhibition Workarounds at Gallery Goloss, Cph (2010) and Katastrophenalarm at NGBK, Berlin (2008). **http://www.field-work.dk**

Yevgeniy Fiks (Reading Lenin with Corporations) was born in Moscow, Russia, and has lived and worked in New York, USA, since 1994. Fiks has produced many projects on the subject of the post-Soviet dialog in the West and has exhibited them internationally. Since 2008, he has been collaborating with Olga Kopenkina and Alexandra Lerman on Reading Lenin with Corporations. **http://www.yevgeniyfiks.com**

flo6x8 are based in Seville, Spain. flo6x8 started their performance flamenco music and dance in bank offices after the collapse of Lehman Brothers. As a form of art civil disobedience, flo6x8 encourages people to occupy those places all over the country pointing at their vulnerability. The *Flo6x8: Body versus Capital* documentary presents the group's performances as well as the surveillance images from various banks.
http://www.flo6x8.com

Melanie Gilligan is an artist and writer born in Toronto in 1979. Her writings on art, politics, and finance have appeared in journals and magazines such as *Grey Room*, *Texte zur Kunst*, *Artforum* and *Fillip* and in edited volumes such as *Canvases and Careers Today* (Sternberg Press) and *Intangible Economies* (Fillip). Her work as an artist incorporates a variety of media including video, performance, writing, installation, and music but her particular focus in recent years has been on writing and directing narrative video works and performances, using these media as experimental means of thinking through practice. Gilligan completed a BA (Hons) Fine Art at Central Saint Martins in 2002 and attended the Whitney Museum of American Art's Independent Study Program in 2004–05. Solo exhibitions include Kolnischer Kunstverein (Cologne), Chisenhale Gallery (London), The Banff Centre (Banff), Transmission Gallery (Glasgow), Presentation House Gallery (North Vancouver), Franco Soffiantino Gallery (Turin), Justina M. Barnicke Gallery (Toronto), and VOX (Montreal).

David Graeber's original research project focused on relations between former nobles and former slaves in a rural community in Madagascar; it was about magic as a tool of politics, about the nature of power, character, and the meaning of history. He has also worked extensively on value theory, the ethnography of direct action, and the history of debt. He is currently Reader in Social Anthropology at Goldsmiths, University of London.

Jan Peter Hammer was born in Kirchheim unter Teck, Germany, and lives and works in Berlin, Germany. In 2003 he graduated in fine arts (MFA) at the Hunter College New York. Recent solo exhibitions include Elizabeth Dee Gallery, New York; Galerie Meerrettich, Berlin, and Supportico Lopez, Berlin. His films were shown at film festivals such as DOK Leipzig and the International Film Festival Rotterdam.
http://www.jphammer.de

Alicia Herrero was born in Buenos Aires, Argentina, and lives and works in Buenos Aires. Herrero founded the Laboratory of Investigation in Contemporary Artistic Practices at Buenos Aires University (UBA), and *Magazine in Situ*. Her *Art & Capital* series was exhibited at Museum Boijmans van Beuningen, Rotterdam; Shedhalle, Zurich; Neue Gesellschaft für Bildende Kunst NGBK, Berlin, and the Modern Art Museum of Buenos Aires (MAMBA).
http://www.aliciaherrero.com

Brian Holmes, PhD, is an art critic, activist, and translator, living in Paris, interested primarily in the intersections of artistic and political practice. He holds a doctorate in romance languages and literatures from the University of California at Berkeley. Brian Homes has been the English editor of publications for *Documenta X*, Kassel, Germany, since 1997. Brian was a member of the graphic arts group Ne pas plier from 1999 to 2001, and has worked with the French conceptual art group Bureau d'Études.

Pia Hovi-Assad lives and works in Pori, Finland. She has worked as a curator in the Pori Art Museum since 2009. In her curating, Hovi-Assad has focused in particular on contemporary artists whose work explores ecological issues, forms of resistance, migration and racism. Working together with local community organizations, she has realized art projects and has also organized events, seminars, and screening series in cooperation with artists. She has edited and contributed to several publications issued in the Pori Art Museum publication series.

Institute for Wishful Thinking (IWT) is a collaborative group of New York City- based artists working together since 2009 and includes Maureen Connor, Andréa DeFelice, Susan Kirby, Karl Lorac, Matt Mahler, John Pavlou, Nathania Rubin, and Gregory Sholette.
http://www.theiwt.com

Olga Kopenkina (Reading Lenin with Corporations) is a New York-based, Belarus-born curator and critic of contemporary art. Graduated from Bard College Center for Curatorial Studies, she curated a number of exhibitions in US and Russia, exploring the relationship between art and politics. She has collaborated with Yevgeniy Fiks and Alexandra Lerman on the project Reading Lenin with Corporations since 2008.

Alexandra (Sasha) Lerman (Reading Lenin with Corporations) was born in St Petersburg, Russia, and lives and works in New York, USA. Lerman's photography, film and installation work aims to allegorize the news and forge personal connection to geo-political events. Lerman's solo and collaborative projects have been shown at Storefront for Art and Architecture, Anthology Film Archives, Artists Space and New Museum in New York, and MUSAC in Spain, among other venues.
http://www.alexandralerman.com
http://www.alexandralerman.com/rlwc-2012

Kirsten Lloyd is Associate Curator at Stills, Edinburgh. She is currently curating a three-year program of exhibitions, research workshops, and residencies entitled *Social Documents* which examines the turn towards documentary modes in contemporary art. Following *The Ethics of Encounter* (2010/11) and a solo presentation by Allan Sekula (2011/12), the trilogy will conclude in 2013 with an exhibition, co-curated with Angela Dimitrakaki, entitled *ECONOMY* which examines the recent emergence of economy as the key factor in shaping human life.

Sherry Millner and Ernie Larsen were born in New York (Millner) and Chicago (Larsen), and live and work in New York, USA. Millner and Larsen have produced several situationist films, two anti-documentaries redefining crime, and a series of semi-autobiographical videos focusing on the authoritarian structures indispensable to capital. Millner is also an installation artist and photomonteur; Larsen a novelist and media critic.

Liz Park is an independent curator and writer committed to creating discursive spaces and generating forums to engage an audience with discussions of contemporary political and social realities. She received an MA in curatorial studies at the University of British Columbia in 2007, and in 2011/12, she was Helena Rubinstein Fellow in the Curatorial Program at the Whitney Independent Study Program.

Oliver Ressler was born in Styria, Austria, and lives and works in Vienna, Austria. Ressler is an artist and filmmaker, and his projects on economics, democracy, forms of resistance, and social alternatives have been in solo exhibitions at the Berkeley Art Museum, USA; Platform Garanti Contemporary Art Center, Istanbul; Alexandria Contemporary Arts Forum, Egypt; Bunkier Sztuki Contemporary Art Gallery, Krakow, and at the biennials in Prague, Seville, Moscow, Taipei, Lyon, and Gyumri. He is the editor of the book *Alternative Economics, Alternative Societies* (2007).
http://www.ressler.at

Damon Rich's exhibitions, graphic works, and events, sometimes produced in collaboration with young people and community-based organizations, build fantastical spaces for imagining the physical and social transformation of the world. His work represented the United States at the 2008 Venice Architecture Biennale, and has been exhibited at PS 1 Contemporary Art Center, the Canadian Centre for Architecture, and the Netherlands Architecture Institute. In 1997, he founded the Center for Urban Pedagogy (CUP) and was Executive Director for ten years. **http://www.damonrich.net**

John Roberts is Professor of Art & Aesthetics at the University of Wolverhampton. He is the author of a number of books, including *The Intangibilities of Form: Skill and Deskilling in Art After the Readymade* (2007) and *The Necessity of Errors* (2011). He lives in London.

Isa Rosenberger was born in Salzburg, Austria, and lives and works in Vienna, Austria. In her video projects and installations she is particularly interested in political upheaval and both its social as well as economic consequences, often with a specific focus on a post-socialist Europe. Recent exhibitions include Grazer Kunstverein (solo); Secession, Vienna (solo); Edith Russ Site for Media Art, Oldenburg; Galerija Nova, Zagreb; Galerija Miroslav Kraljevic, Zagreb, and the Museum of Contemporary Art Leipzig.

Dread Scott was born in Chicago, USA, and lives and works in New York, USA. Scott makes revolutionary art to propel history forward. In 1989, the entire US Senate denounced his artwork and President Bush declared it "disgraceful" because of its use of the American flag. His work has been exhibited at the Whitney Museum, MoMA/PS1 and galleries and street corners across the country.
http://www.dreadscott.net

Gregory Sholette is an artist, activist, and author based in New York. He co-founded two artists' collectives: Political Art Documentation and Distribution (1980–88) and REPOhistory (1989–2000). He is the author of *Dark Matter: Art and Politics in the Age of Enterprise Culture* (2010), and co-editor of *Collectivism after Modernism: The Art of Social Imagination after 1945* (2007) and *The Interventionists: Users' Manual for the Creative Disruption of Everyday Life* (2004).

Kerstin Stakemeier (Berlin/Munich) studied political science in Bremen/Berlin (1995–99) and art history in Berlin/London (1999–2004). From 2009 to 2010 she was a researcher at the Jan van Eyck Academie, Netherlands, where she worked on Realism in modern and contemporary art. She completed her PhD *Entkunstung – Artistic Models for the End of Art* at University College London in 2011, which she is currently making into a publication with b_books, Berlin. She works as a researcher, lecturer, curator, and writer for Phase2, Texte zur Kunst, Springerin, Artforum, and others, was initiator of the Aktualisierungsraum in Hamburg with Nina Köller in 2007/08 and has continued this structure in varying formats with Eva Birkenstock since and collaborates regularly with the artist Johannes Paul Raether. She holds a junior professorship at the cx centrum for interdisciplinary studies at the Academy of Fine Arts Munich.

Superflex is an artists' group founded in 1993 by Jakob Fenger, Rasmus Nielsen and Bjørnstjerne Christiansen. Superflex describe their projects as Tools. A tool is a model or proposal that can actively be used and further utilized and modified by the user. Recent solo exhibitions include Van Abbe Museum, Eindhoven; South London Gallery, London, and Redcat Gallery, Los Angeles.
http://www.superflex.net

Slavoj Žižek, PhD, is a senior Researcher at the Institute of Sociology, University of Ljubljana, Slovenia, and a visiting Professor at a number of American universities (Columbia, Princeton, New School for Social Research, New York University, University of Michigan). Slavoj Žižek recieved his PhD in philosophy in Ljubljana studying psychoanalysis. He also studied at the University of Paris. Slavoj Žižek is a cultural critic and philosopher who is internationally known for his innovative interpretations of Jacques Lacan.

The Performance Artists
Aaron Burr Society
http://www.aaronburrsociety.org
Larry Bogad
http://www.lmbogad.com
Pablo Helguera
http://pablohelguera.net
Occupy Museums
http://occupymuseums.org